LYE & WOLLESCOTE

A FOURTH SELECTION

PAT DUNN & COLIN WOOLDRIDGE

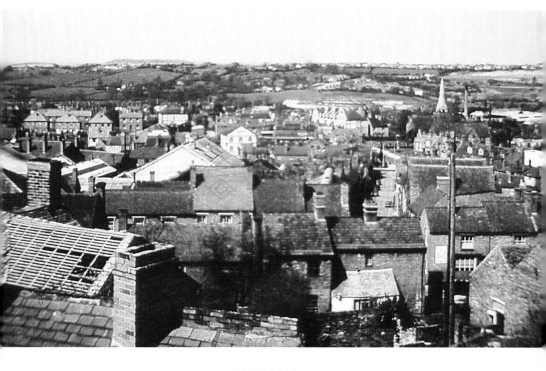

The History Press

Previous page A panoramic view of Lye taken in the 1960s from the Waste before demolition work commenced. The steeple of Christ Church and the war memorial can be seen (centre left), also the Rhodes Buildings a little further along the High Street. Housing now covers much of the rural area.

First published 2013

The History Press
The Mill, Brimscombe Port
Stroud, Gloucestershire, GL5 2QG
www.thehistorypress.co.uk

© Pat Dunn and Colin Wooldridge, 2013

The right of Pat Dunn and Colin Wooldridge to be identified as
the Authors of this work has been asserted in accordance with the
Copyright, Designs and Patents Act 1988.

British Library Cataloguing in Publication Data.
A catalogue record for this book is available from the British Library.

ISBN 978 0 7524 7971 2

Typesetting and origination by The History Press
Printed in Great Britain

CONTENTS

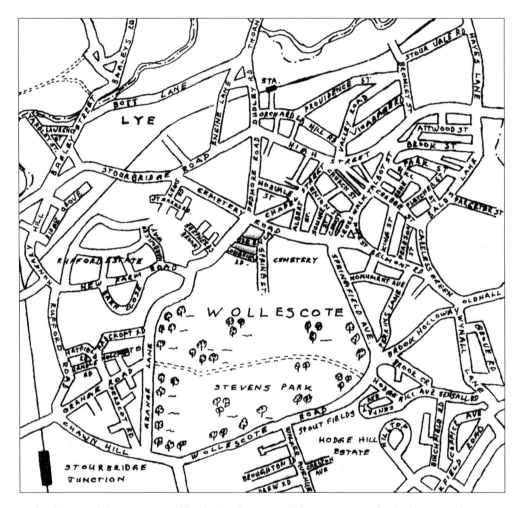

A sketch map of the area covered by this book. Many of the streets completely disappeared in the widespread redevelopment from the 1960s onwards.

INTRODUCTION

The three Black Country communities featured in this book all bear names of Saxon origin – Lye meaning pasture, Wollescote, Wulhere's cot, and Stambermill, stepping-stone brook mill. They were formerly in the ancient parish of Old Swinford and, before the reorganisation of local government in the late nineteenth century, under the secular jurisdiction of Hales Owen.

Except for a brief period during the Civil War when Wollescote Hall was the local headquarters of Prince Rupert, life was uneventful, that is until the end of the seventeenth century when gypsies descended on the Waste, the uncultivated land beyond Lye proper which was centred around the Cross. Attracted by the area's prosperity and its raw materials – namely coal and fireclay – the newcomers built themselves crude mud houses; 103 were recorded on Waste Bank in 1699. As a result Lye is still often called Mud City. Although they settled and earned an uncertain living in the local trade of nailmaking, the Lye Wasters failed to integrate with their Lye neighbours, by whom they were regarded as a lawless and Godless lot.

In 1790 the Revd James Scott, a Unitarian Minister from Netherend, was the first to exercise a civilising influence on the Waste, eventually building a permanent chapel there in 1806. In 1813 Thomas Hill, a local benefactor, was instrumental in the founding of an Anglican church fortuitously sited midway between the two settlements, thus encouraging their integration and bringing beneficial influences to bear on the Lye Wasters. It became the parish church in 1843. Wollescote was served by the Belmont Mission which was opened in 1878.

Various other religious groups were active locally in the nineteenth century, particularly the Methodists; a Wesleyan Chapel was erected in 1818, Primitive Methodist Chapel in 1831, Gospel Hall in 1884, Bethel Chapel in 1890, Salem Chapel in 1893 and Hayes Lane Chapel in 1896. A Congregational church was built in 1827. The Salvation Army also had an enormous impact when it appeared in 1881. All religious groups were zealous in providing opportunities for a basic education and the Non-Conformists in particular also offered their congregations experience in democratic organisation, self-expression and self-help.

From the 1840s, when the major occupation of nailmaking by hand was ruined by foreign competition and mechanisation, other industries developed. However, the invention of the frost cog (a device fitted into a horseshoe to prevent the animal slipping in frosty or snowy weather) by Henry Wooldridge of Lye in 1880, ensured that one facet of the trade survived. The first local factory, built in 1770, was Thomas Perrins' chain works at Careless Green, but there were also small vice, anvil, spade and shovel works. The band of superior fireclay running from Wollescote to Kingswinford led to the manufacture of firebricks, furnace linings, crucibles for the glass industry, and both plain and ornamental house bricks. Lye High Street still boasts fine edifices composed of the latter two products, particularly the Centre, Rhodes, and Bank Buildings.

However, it was the manufacture of hollow-ware which was to replace nailmaking as the prime Lye industry. In the latter years of the nineteenth century, buckets, baths, trucks and boxes were made. The labour force was cheap, plentiful and expert at handling metal. Technical advances, particularly galvanising, introduced in 1863 by eighteen-year-old George Hill, led to further expansion and to Lye's other nickname, the 'Bucket Capital of the World'. Vitreous enamelling was later to become as popular as galvanising. However, in the twentieth century, plastics and other synthetics were to ruin this trade.

Factories introduced discipline, orderliness and a more secure income to the working population; there was also more time for leisure activities. In earlier days sports and pastimes had been bloodthirsty ones – bull-and badger-baiting, bare-knuckle fighting and cock-and dog-fighting (though these latter two persisted illegally in Lye well into the twentieth century). However, the influence of church and chapel introduced more civilised amusements including football and cricket teams, Scouts and Guides, cultural classes, concerts, and anniversary celebrations. Public houses had always abounded. In 1866 there were reputedly fifty-three pubs to serve a population of 7,000. These also began to field their own cricket and football teams, as well as organise pigeon clubs, domino and dart matches, social trips and treats. In 1874 the Temperance Hall was built, followed by the Vic in 1913, both of which staged a variety of entertainments. The Clifton cinema opened in 1937. The annual carnivals in aid of the Corbett Hospital attracted tremendous support.

The entire community benefited greatly from the opening of a public park, the gift of local industrialist Mr Ernest Stevens, who handed it over to the Lye and Wollescote Urban District Council in 1932. This body had been formed under new local government legislation in 1897; its members were forward-looking individuals who tackled slum clearance, introduced efficient sewerage disposal facilities and water supply to existing homes, and built new council houses. Streets were improved by proper paving, lighting and cleaning. In 1933 the council was disbanded when the area was incorporated into the Borough of Stourbridge.

Their involvement in church and chapel affairs encouraged Lye folk to enter local and national politics, to rise high in professions, and to become inventors, artists, photographers, poets and actors. Many served the church, one became an archbishop, others ministers and missionaries. Two 'outsiders' who came to know the area immortalised Lye in literature – Annie S. Swan in her book *A Bitter Debt* and Sabine Baring-Gould in his *Nebo the Nailer*. Both provided vivid descriptions of the town in earlier days, a Lye barely recognisable after the massive redevelopment of the 1960s.

This volume has attempted to recapture glimpses of that Lye, including Wollescote and Stambermill.

Pat Dunn, 2013

1

STREETS

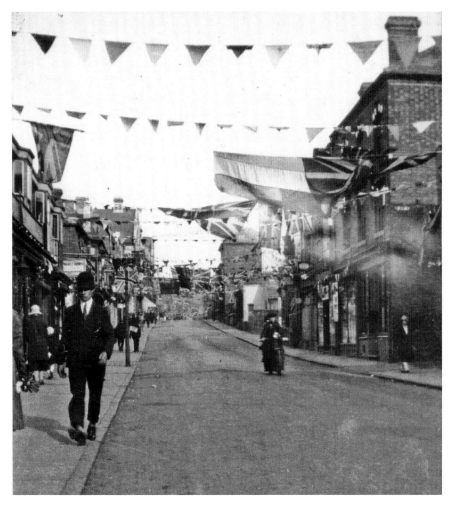

A view of Lye High Street taken from Lye Cross showing it decorated for the 1928 Carnival in aid of Corbett Hospital. The lack of traffic is very noticeable.

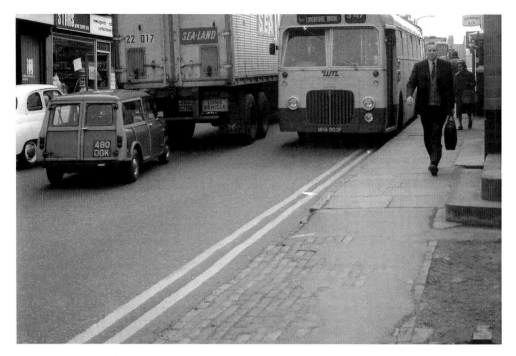

Lye High Street in the mid-1960s. This photograph is interesting because it shows traffic, some of which is heavy, moving both ways and avoiding traffic parked on the roadside.

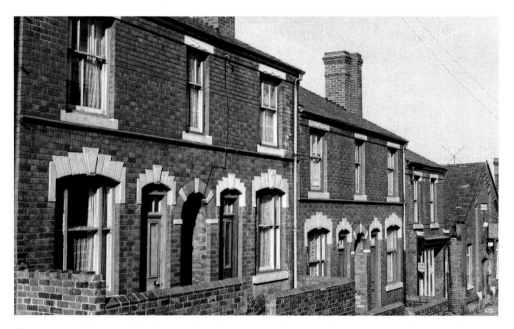

View of Church Street showing houses built at the turn of the nineteenth and beginning of the twentieth century, and also the old Salvation Army citadel on the far right. Note the small general stores wedged between the houses and citadel advertising Lyons cakes. Most Lye streets boasted a little shop or shops.

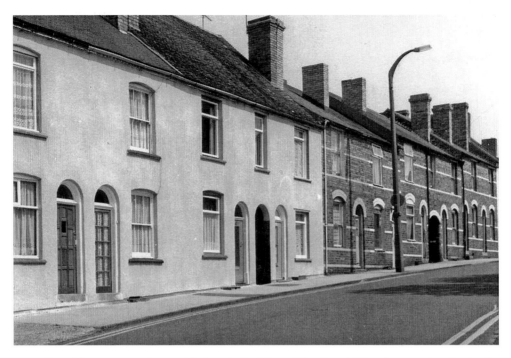

Chapel Street, once a dirt track before the building of the chapel. This photograph, taken in the 1970s, shows a row of late Victorian houses which still stand.

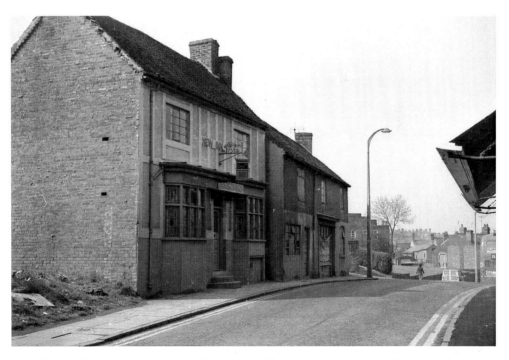

Upper High Street showing the New Inn public house awaiting demolition in the massive 1960s redevelopment.

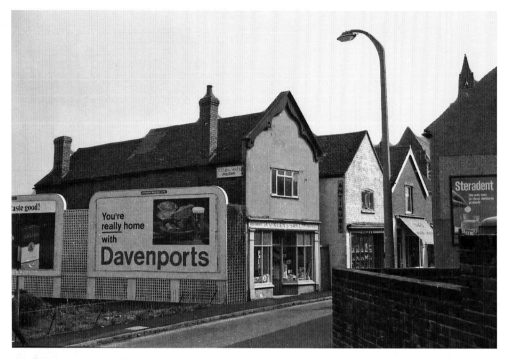

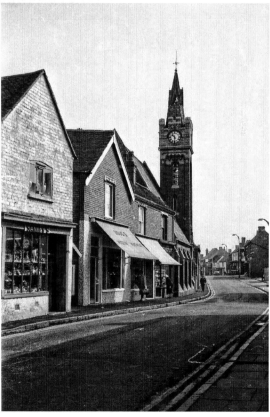

Above Another 1960s view of Upper High Street showing some of the shops below the Unitarian Chapel, the tower of which is visible on the right. One of the shops is Sankey's second-hand and antique shop.

Left The Upper High Street showing shops still open and the Unitarian Chapel tower with its little steeple and clock commemorating the coronation of Elizabeth II in 1953.

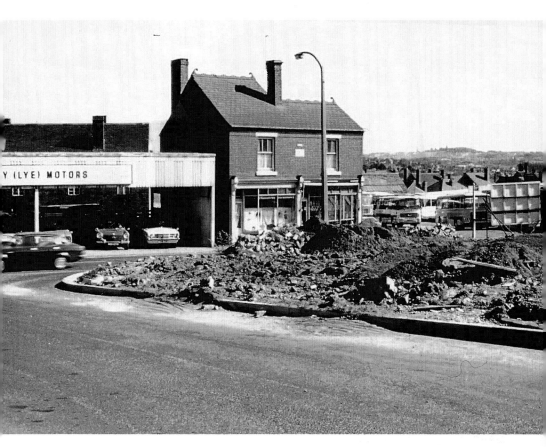

The Knob, 1960s. This is actually Upper High Street but Lye folk referred to the section between Valley Road and Talbot Street junctions as The Knob. Premier Motors (aka Why (Lye) Motors) and Watts's Garage were both still in business, although the shops were closed ready for redevelopment.

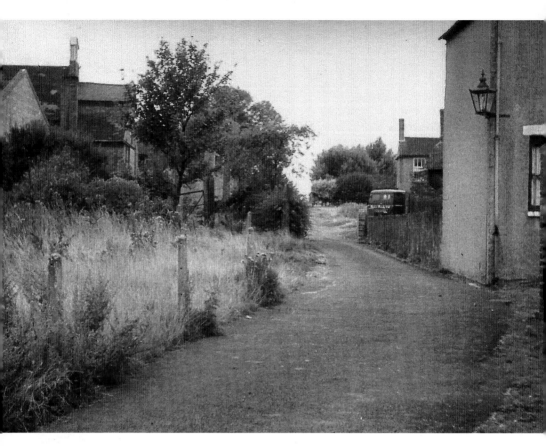

An interesting view of Waste Bank, *c.* 1957. Originally settled by itinerants in the seventeenth century, it was a patchwork of their mud huts – or at least a chimney with a fire – built from local clay. The occupants earned their living by nailmaking and were regarded with suspicion by the native inhabitants until the Revd Mr Scott, the Unitarian Minister, helped 'civilise' them. The Waste earned the area the title Mud City, but by the twentieth century only one mud hut remained and that has now gone.

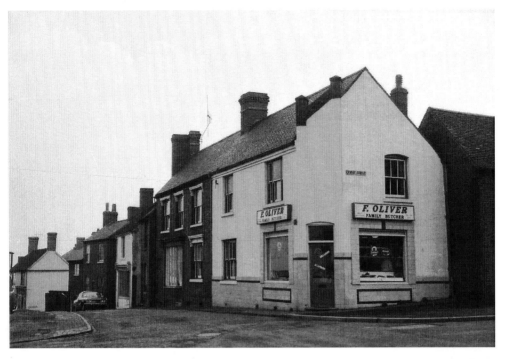

Talbot Street showing the old established butcher's shop on the corner of Crabbe Street, a very popular enterprise run by Mr Chance for many years before the redevelopment of the area.

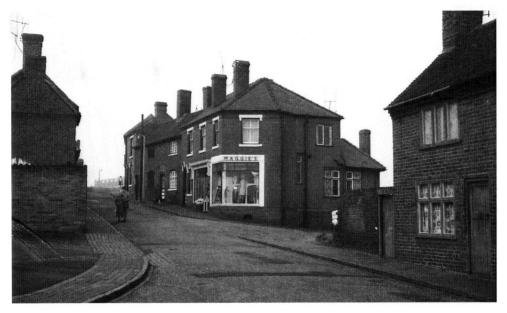

Cobbled pavements appear in this pre-development photograph of Maggie's celebrated drapery shop in Talbot Street. It is obviously a road not much bothered by traffic, as shown by the two ladies enjoying a chat. The small bricks indicate that the house on the left was built in the eighteenth century.

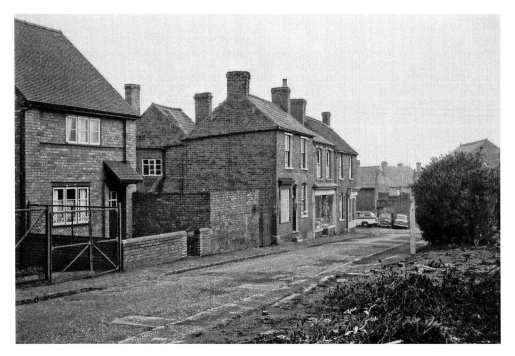

Another view of Talbot Street at the start of redevelopment. The little Victorian shops are still struggling but judging by the rubble on the opposite side of the road, their end is near.

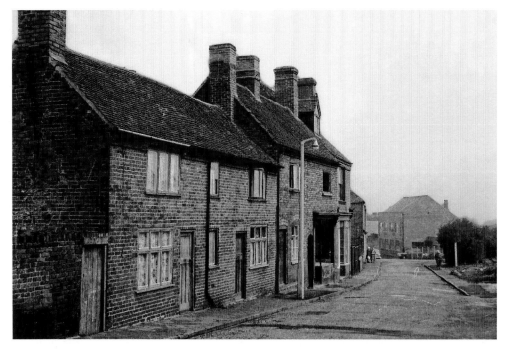

A row of old cottages in Talbot Street. The small bricks again suggest a great age of those on the left. The taller ones adjoining them are probably Victorian, judging by the shape of the doorway.

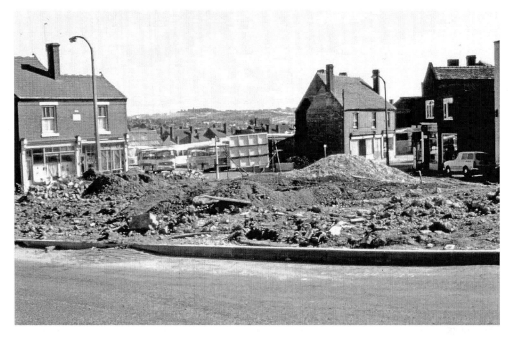

The corners of Pump Street and Talbot Street are shown at the commencement of the redevelopment of the Waste. Hayes Coach business can be seen towards the centre of the photograph and still occupies the same site, though much expanded.

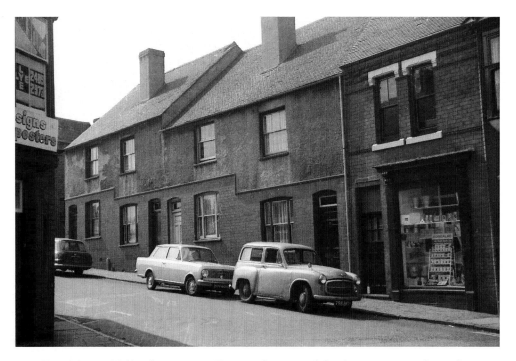

Pump Street, 1960s, showing neat Victorian houses and Case's ironmongery shop, where one could buy anything from a single screw to massive items.

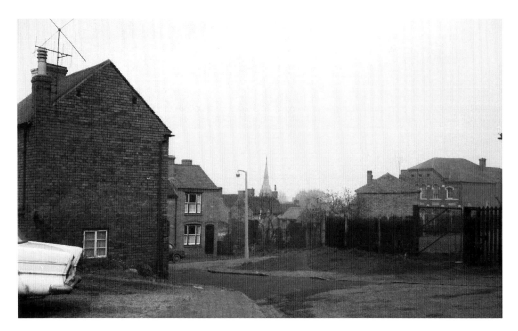

Yet another street which disappeared once the 1960s redevelopment got underway. This is Pope Street, a steep little roadway connecting Belmont Road and Cross Walks. Note the steeple of Lye Church (centre) and the Primitive Methodist Chapel (right) – also the old house on the left constructed of small, locally made bricks, and the cobbled pavement.

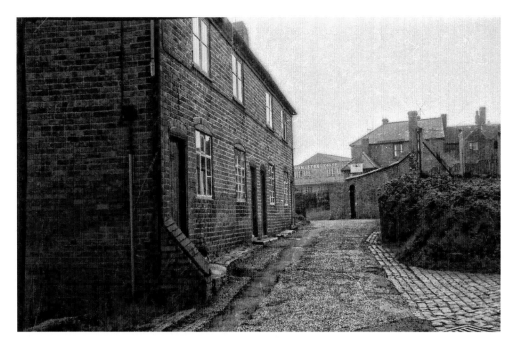

Fanny's Lane, one of Lye's oldest thoroughfares, long before the days of tarmacadam and street lighting. It linked two other old tracks – Connop's Lane and Skeldings Lane. Note the locally made house bricks, the cobbled pavement and the sorry state of the lane itself.

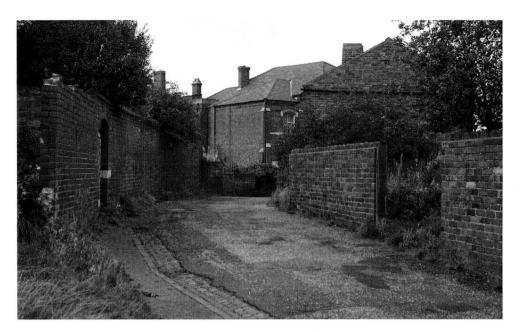

Another view of Fanny's Lane showing the original cobbles partially covered with more modern tarmacadam and, apart from the central building, a general air of neglect. Redevelopment is not far away.

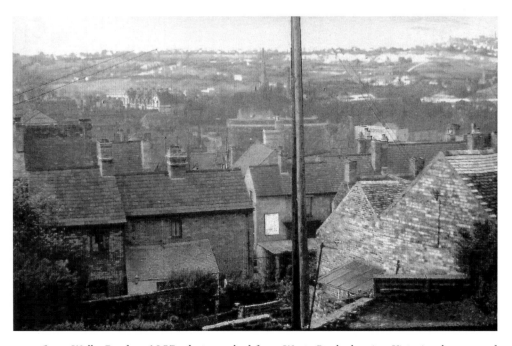

Cross Walks Road, c. 1957, photographed from Waste Bank showing Victorian houses and beyond them the Clifton Cinema (right) and Christ Church (centre). The far horizon, then semi-rural, is now heavily built upon.

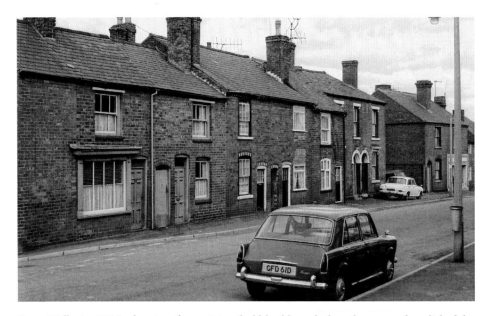

Cross Walks in 1966, showing the variety of old buildings before they were demolished for modern housing. Built of local bricks they superseded some of the original mud huts, which sometimes were later encased with bricks. None of the dwellings are large and most have 'entries' to the backs of the premises. The one on the extreme left would probably have been a shop in earlier times.

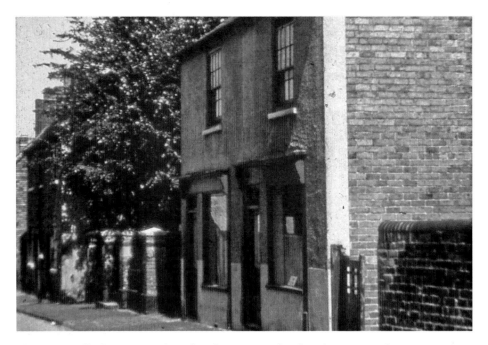

The Cross Walks by Mount Tabor Chapel entrance. The chapel was erected on Lye Waste in 1872 but closed in 1964 and was demolished. Its congregation moved to St John's Chapel in Chapel Street.

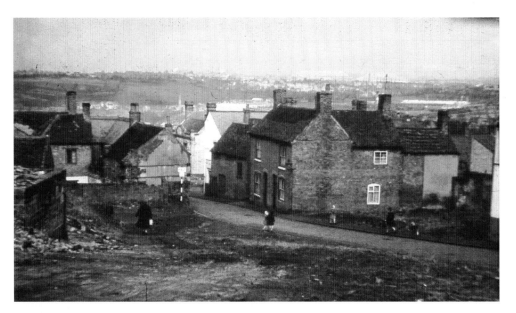

Above A panoramic view of Crabbe Street, Wollescote, as redevelopment gathers pace. The houses in the centre appear to be still inhabited amid the surrounding chaos.

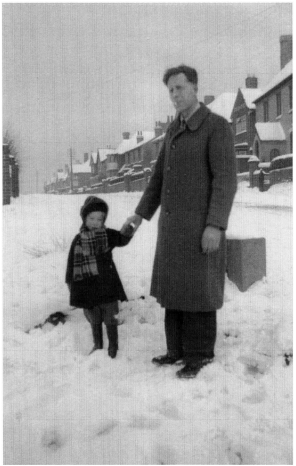

Left Perrins Lane in the terrible winter of 1947. Bill Pardoe, one of Lye's great worthies, is seen here with his son braving the wintry weather. To Bill's right is a much-altered old house which boasted a chain shop.

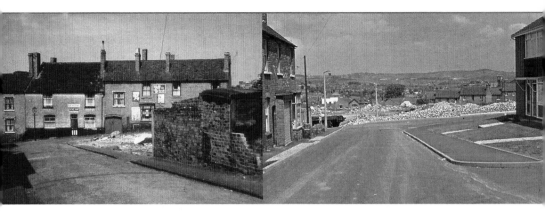

Two views of Summer Street situated on the left-hand side towards the top of Cemetery Road. The photograph on the left shows it during the pre-1960s redevelopment and the right-hand one afterwards. Fortunately some of the old houses still stand.

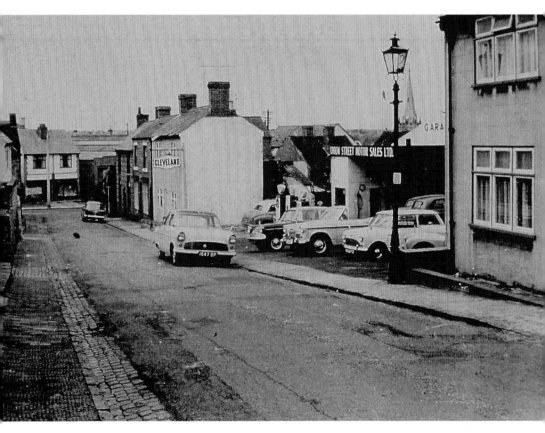

Union Street photographed prior to redevelopment. It was an old road connecting Cross Walks with Chapel Street in which two shops can be seen. In Union Street itself is the Cleveland Garage and Union Street Motor Sales, selling Minis and Ford Anglias. Note the old lamp-post and the cobbled area of the street, and also the blue brick pavement. The steeple of Lye Church is visible on the right.

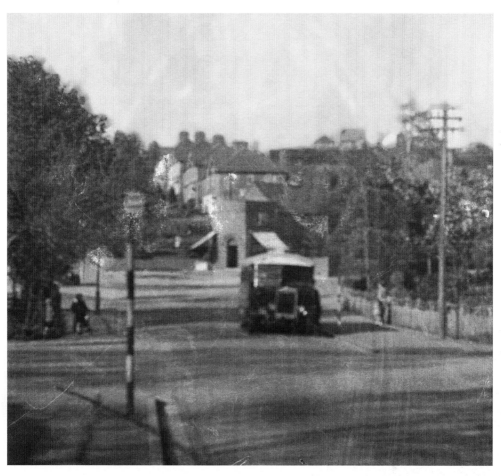

A rare view of the Spout looking towards Perrins Lane with Wollescote Road to the left and Brook Holloway to the right, completing the crossroads. The Spout, or Spring, had been in existence since time immemorial but temporarily stopped running when sewers for the new Springfield Road were laid in 1931. This photograph probably dates from that era, judging by the design of the bus.

Grange Lane showing the Noah's Ark. Now called the Hadcroft, it was built to replace the original public house and was renamed after the nearby Hadcroft brickworks which, like the hollow-ware factory on the right-hand side, has long since disappeared.

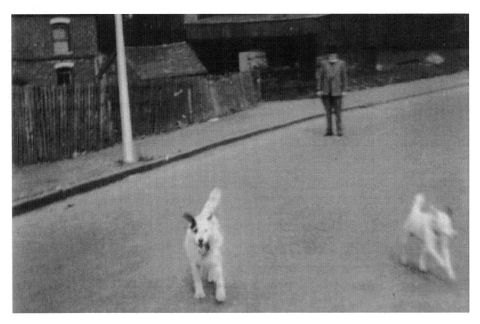

The Revd Mr Smith, vicar of Christ Church, Lye, exercising his dogs in Providence Street in the 1940s. Behind him are the Evesons works and to the left the manager's house. Obviously traffic was rare, except for Bantocks horse and carts transferring finished goods to Lye railway station for delivery to customers.

2

BUILDINGS

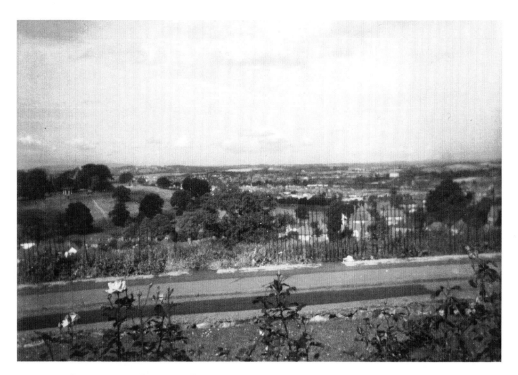

A mid-1930s snapshot of Wollescote Park and bandstand given to the local people by Ernest Stevens, the wealthy Lye industrialist, in 1932. It is taken from the garden of the recently built council houses in Wynall Lane, Wollescote.

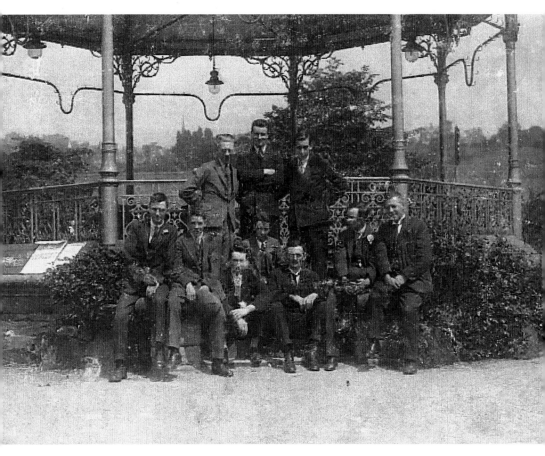

The bandstand in Wollescote Park was opened by Wesley Perrins on 5 August 1933 and was erected by Lye and Wollescote Urban District Council. It was created by Futuristic Design, Worcester. The band of the 7th Battalion of the Worcestershire Regiment entertained the spectators. It was demolished in October 1979 due to vandalism. The park itself opened in 1932.

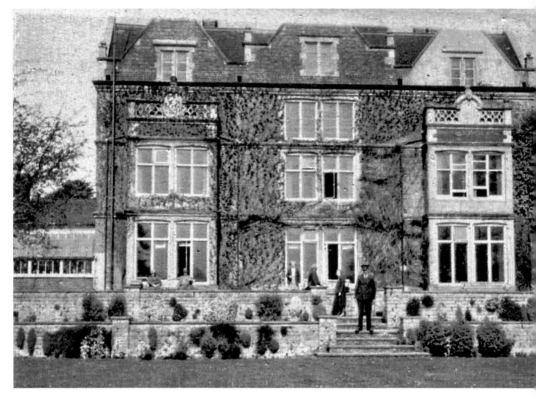

Wollescote Hall, photographed in the 1930s, originally the home of the wealthy Milward family in the seventeenth century, was built on the site of an earlier timber-framed building. During the Civil War it was the area headquarters of Prince Rupert. Altered in the Victorian era, the hall and its grounds were presented to Lye & Wollescote Urban District Council as a public park by local industrialist, Ernest Stevens. Note the park keeper on the steps.

A rare photograph of the park-keeper's lodge at Wollescote Park. The building itself has disappeared, but the gatepost to its left remains.

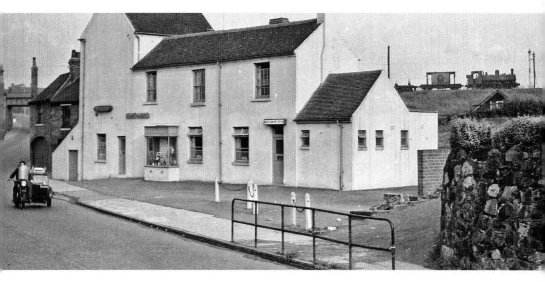

The Heart in Hand public house in Stambermill, 1930s. Note the railway line at the rear – the Stourbridge Junction to Birmingham route – complete with a steam engine, freight and signals.

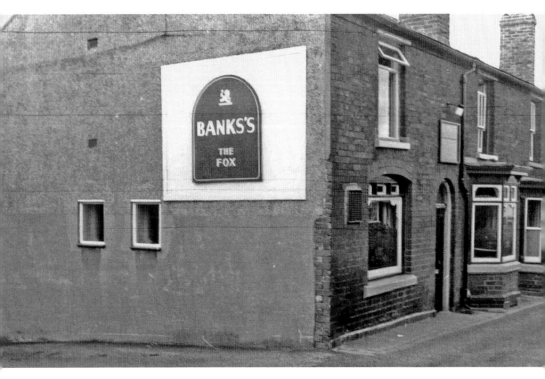

The Fox public house, Green Lane, photographed in 1978. It still stands, not much altered, and is one of four pubs in close proximity. In 1900 Lye boasted a total of 69 pubs and 55 clubs within half a mile of each other.

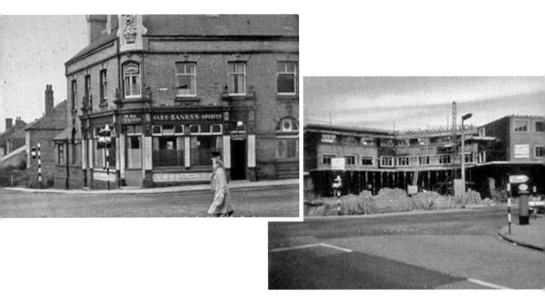

The prestigious Victorian inn, the Rose & Crown on Lye Cross, was better known as the 'Mercy Bar' because of the hitching rail outside similar to those seen outside American bars. Like the buildings around it, it was demolished in the massive 1960s redevelopment of the area.

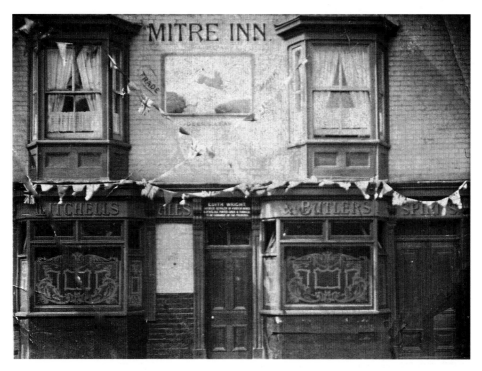

The Mitre Inn, High Street, Lye. No date is available for this very old photograph, taken when Edith Bright was the licensee. The leaping deer painting was the trademark of the brewery company, Deer's Leap.

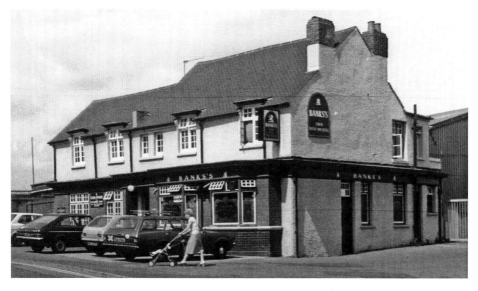

A 1970s photograph of the quaintly named public house the Swan with Two Necks in Dudley Road. In 1862 John Heathcock, the publican, organised a society for 'members of a society for helping each other in the funeral expenses of each respective family'. Each member was given a book of rules to be observed.

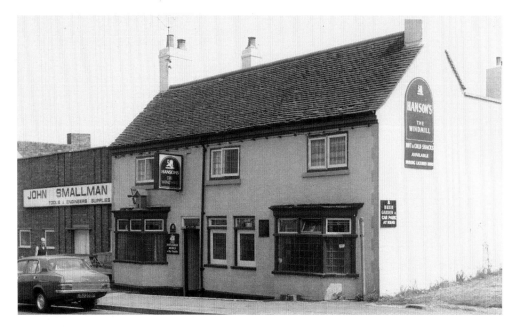

The Windmill Inn, Dudley Road, 1978. This was one of the sixty-nine public houses existing in the area in 1900. Here it is bounded by Smallman's Tool & Engineers Supplies, one of a large number of small businesses in Lye, many of which have now disappeared.

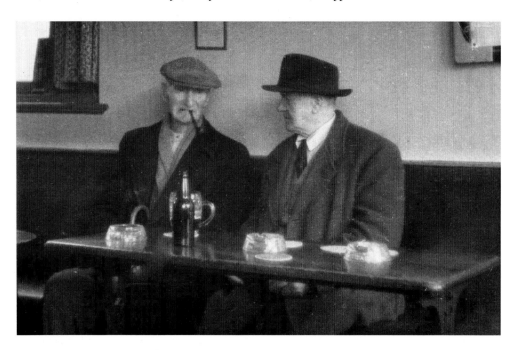

Two men enjoying a pint in the now-demolished Dudley Arms in Lye's Upper High Street, late 1940s. The man in the trilby – known as Johnny – was a relative of the Darbys who kept the greengrocer's next door. Sabine Baring-Gould, the clergyman who wrote *Nebo the Nailer*, the Victorian best seller about Lye, obtained much information from the landlord.

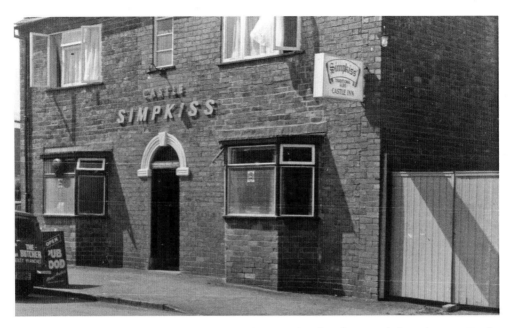

The Castle Inn, Balds Lane, certainly existed in 1900 but this photograph dates from 1978. Like other hostelries it was host to various local clubs including, in its case, Wollescote FC.

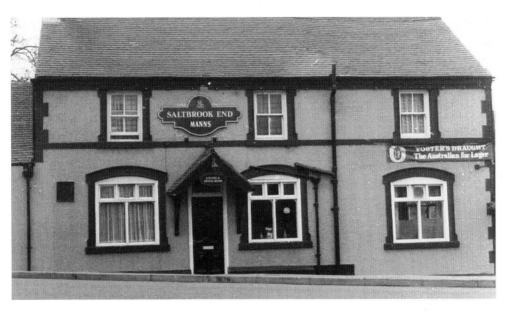

Saltbrook End public house, Hayes Lane, was for a time renamed the Dewdrop. It was frequented largely by the workers of adjacent factories. This photograph shows it in the 1970s.

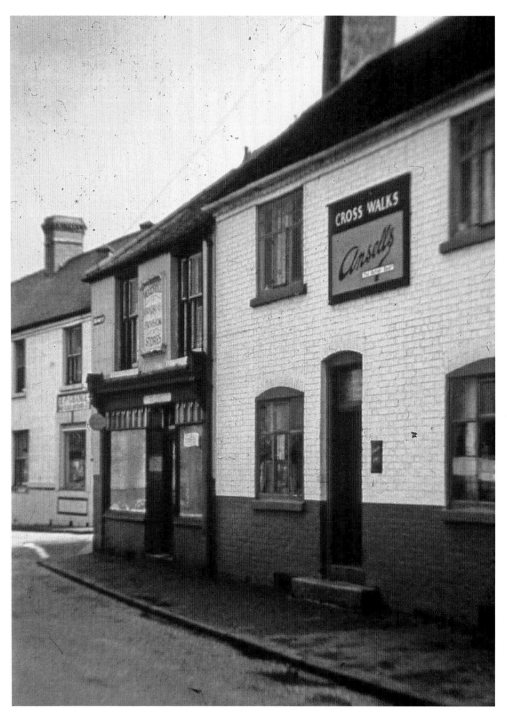

Wooldridge's Bakery in Cross Walks, photographed shortly before the destruction of the whole area in the 1960s. Mr Wooldridge was a prominent Lye businessman in the early twentieth century. His daughter Hilda used to deliver the bread to local families on foot. Also featured is the Cross Walks Inn.

Stan Davies' shop, Talbot Street. A general stores and greengrocer's, it occupied the mid-eighteenth-century Star buildings which comprised the Star public house adjacent to the shop, which was once a dairy with stabling for horses and other outbuildings. It fell victim to the vast redevelopment of the 1960s – a sad loss!

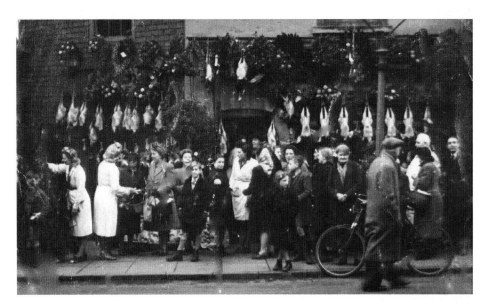

Charlie Darby's greengrocery shop, Upper High Street, caught on camera at Christmas 1947. Charlie is the white-haired gentleman on the extreme right and the lady in the white overall is Jessie Darby. Behind Joan Mobberley, showing a customer a Christmas tree, are Vera Darby and Jimmy Skidmore. Brian Phipson is walking in the road on the extreme right and Mrs Skidmore, landlady of the adjacent Lord Dudley Arms, is behind him.

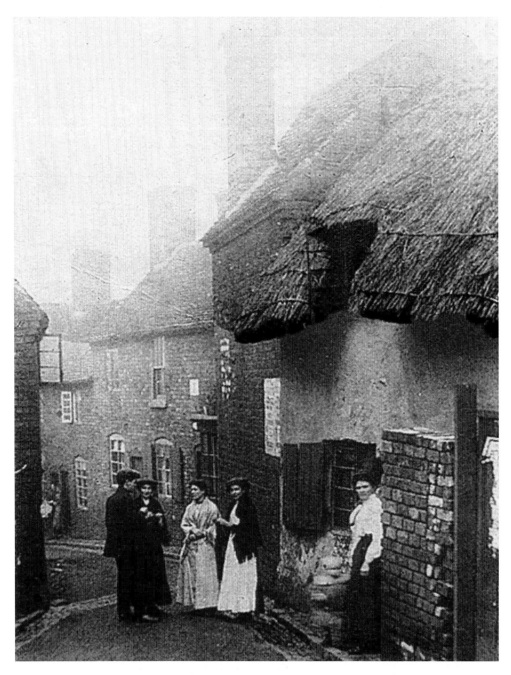

Mud hut, Skeldings Lane, *c.* 1900. In ancient times, if a person could build a dwelling (or a chimney with a fire) on common land in 24 hours he was allowed to live-in rent free. Displaced persons arriving on Lye Waste in the seventeenth century built such huts with the abundant local clay. So many sprang up that the area became known as Mud City. The last mud hut was bulldozed in the 1960s redevelopment – a sad loss to Lye's rich history. No photographs of it or any other have been produced for this book, so included is an iconic photograph from a previous one.

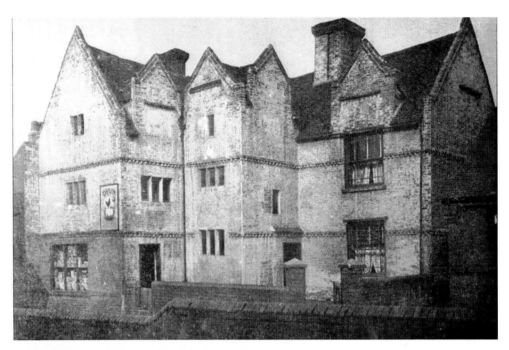

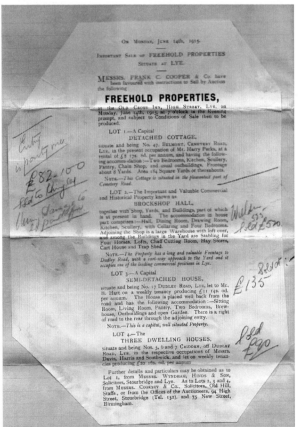

Above Brocksopp's Hall, Dudley Road, Lye. A Jacobean building boasting a priest hole, the hall had a very chequered history before it burned down in 1938. Originally a house, then business premises with living accommodation, it was a haven for Belgian refugees in the First World War.

Left In 1915 Brocksopp's Hall was put up for sale. This is a copy of the sale notice giving details of the property.

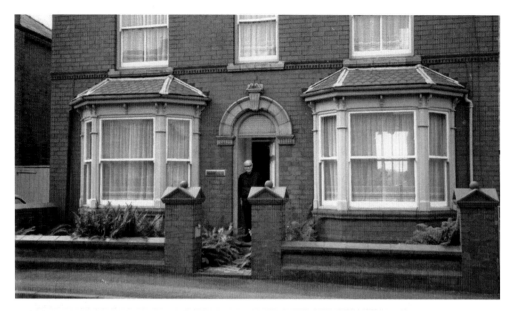

Axholme, Monument Avenue, Wollescote, a late Victorian house built by Mr Foster, partner in the wholesale saddlery shop in Lye High Street. Bought by Mr Dunn, standing in the doorway, in the 1950s it still had many original fittings in working order, including an ornamental gas fire with imitation glowing coals. It is now in the gas museum after gas men spotted it in the 1980s.

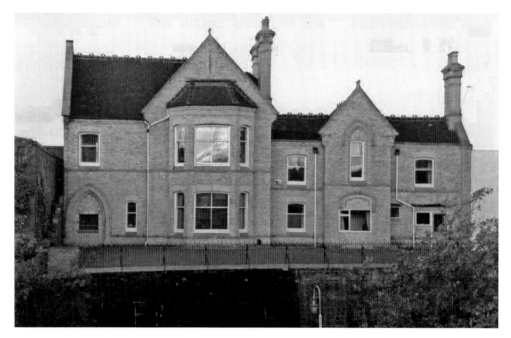

Orchard House, Dudley Road, Lye, was built by local brick manufacturer, George King Harrison in 1863. When the railway came it cut through the long drive into Orchard Lane, but then had a private stairway to the station. In more recent times it became Folkes Forge offices.

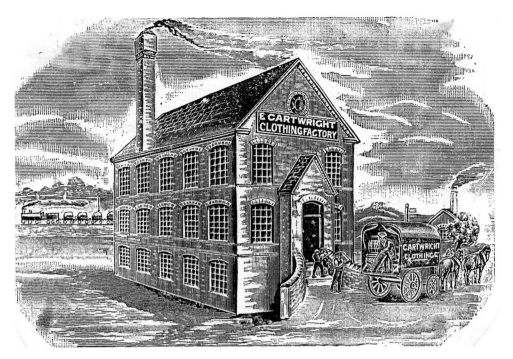

A sketch of Elisha Cartwright's clothing factory which opened in 1897 on Lye Cross, where he also had a shop called Centre Buildings. Originally a miner, he studied tailoring at night school and was so successful he became a highly respected businessman. He named his son Centre after his shop! Note the train in the background.

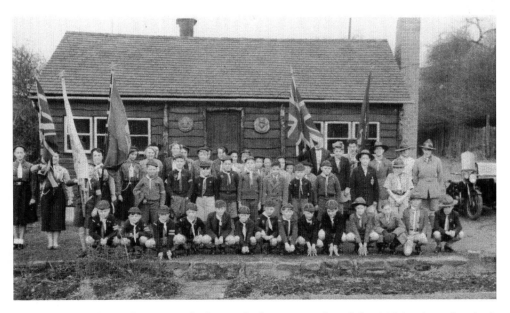

Stambermill Scout hut in Stourbridge Road. The troop was founded in 1914 and members built the hut themselves as their headquarters. This photograph shows it being used by Scouts, Cubs and Girl Guides.

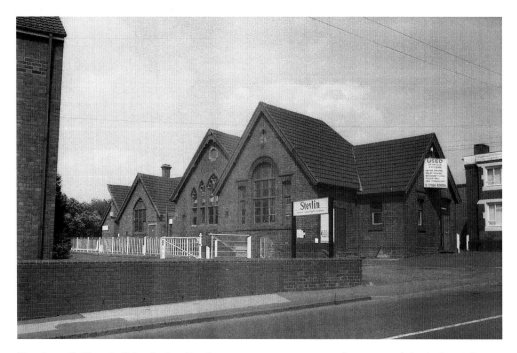

Stambermill Church School after its closure some years ago, to be reopened for industrial use. Built in the mid-nineteenth century it was the brainchild of the Revd James Bromley, the popular vicar of Christ Church, Lye. On his death in 1865, leaving a widow and ten children, the staggering sum of £3,000 was raised for their welfare. His stipend had been £240 per annum.

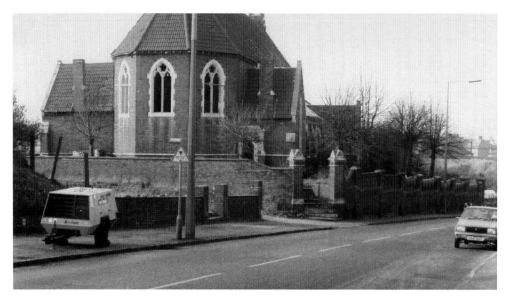

Stambermill St Mark's Church was a sister church to Christ Church, Lye. It was opened in 1870 by Lord Lyttelton of Hagley Hall and was used for church services instead of the school opposite. It was always evangelical in its outlook.

3

CHURCHES & CHAPELS

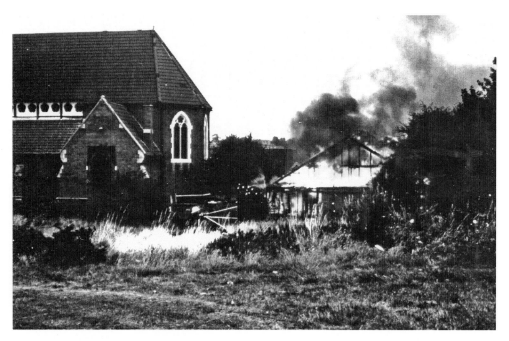

The catastrophic fire which gutted Stambermill Church Hall. The site was used for house-building, as was that of the adjoining church when it was demolished.

Left House of Emmanuel Pardoe in Brook Street, Lye. This was one of the houses used for Bethel Society meetings before the building of the chapel. The society was formed in 1888 when Plymouth Brethren infiltrated Gospel Hall meetings in Hill Street, held by Lieutenant-Colonel Spratt.

Below The Bethel Chapel, Hill Street, designed by Owen Freeman, was opened on 2 April 1900 before the 1920s extension. Its construction cost £600.

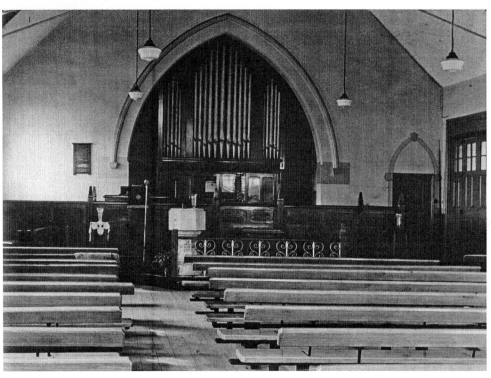

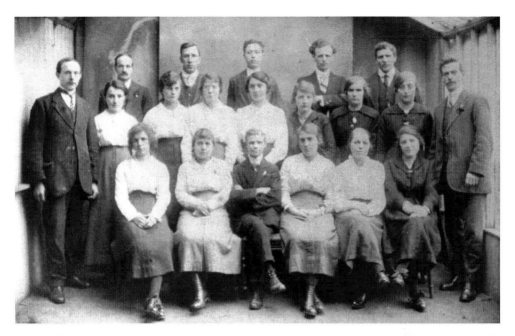

Bethel Choir, early 1900s. Back row, left to right: Will Newey, George Share, -?-, -?-, Will Partridge. Middle row: Fred Dublin (organist), -?-, -?-, Gertie Perks, Nellie Keen, Annie Cheese, Elsie Pearson, -?-, Ted Perks. Front row: -?-, E. Westwood, Bert Parish, Alice Bubbs, Annie Ensow, Sue Dunn.

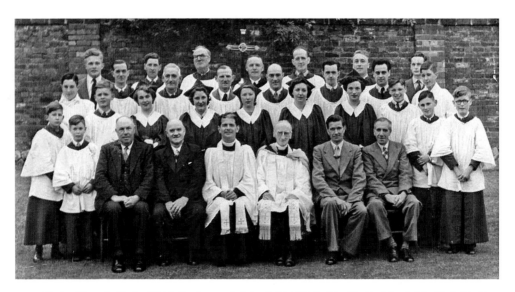

Christ Church Choir, 1948. Back row, left to right: Bill Smith, Mr Bashford, Mr Abel, Mr Cox, Eber Wooldridge, Clarence Chance (organist), Dennis Hart, Mr Holt, Derek Allcock, George Clews, Geoffrey Westwood, Tony Holt. Second row: -?-, -?-, Mary Hill, Phyllis Bottomley, Phyllis Clews, Enid Knowles, Janet Scott, John Wooldridge, -?-, ? Bashford. Front row: -?-, -?-, the Revd Frederick Victery, the Revd. M Stuart-King, -?-, -?-, Peter Fradgley, John Smith, Terry Hart, Trevor Smith.

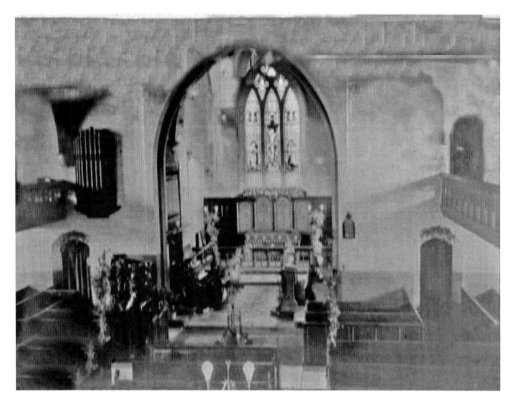

Interior of Christ Church, High Street, Lye. This photograph dates from 1885 when the new spire, designed by Owen Freeman, was built. The original church was built in 1813 as a chapel of ease to Oldswinford Church, but became the parish church in 1843. The interior nowadays is much altered, the galleries and box pews long gone.

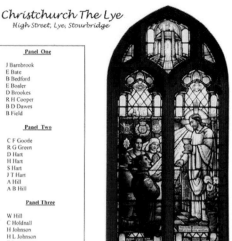

Christchurch The Lye
High Street, Lye, Stourbridge

Panel One

J Barnbrook
E Bate
B Bedford
E Boaler
D Brookes
R H Cooper
B D Dawes
B Field

Panel Two

C F Goode
R G Green
D Hart
H Hart
S Hart
J T Hart
A Hill
A B Hill

Panel Three

W Hill
C Holdnall
H Johnson
H L Johnson
E Jones
E J Keightley
H Kendrick
A T Leighton

Panel Four

I Moss
E Newton
R Pardoe
P Pearson
F J Perks
W H Perry
W E Potter
E Pritchard

Panel Five

J H Rimmer
A H Smith
J Southall
A Taylor
G H Taylor
K Taylor
A Tombs
F Tomkins

Panel Six

E Veal
T Whitworth
F Wooldridge
G R Hart
J T Hurdiss
R Price
E Prosser
W J Simmons
T H Hill

P.E.Lemmon (Fecit)
Bromsgrove AD 1951

Above Stained-glass window in Christ Church in memory of those Lye servicemen killed in the Second World War. It was paid for by public subscription and made by P.E. Lemmon of the Bromsgrove Guild in 1951. D. Hart is the only man for whom no details have been found.

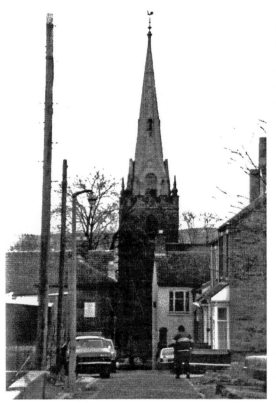

Left A shot of Christ Church taken from Church Road shortly before the removal of the steeple a hundred years after its construction in 1885.

43

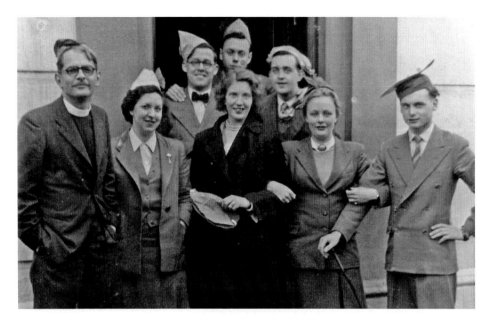

An early 1950s Christmas party at Christ Church, Lye, for the Anglican Young Peoples Association (AYPA). Back, left to right: Malcolm Robinson, Malcolm Noke and Derek Allcock. Front: the Revd Frederick Victery, Enid Knowles, Iris Hall, Pat Wheeler (daughter of Sergeant Wheeler, the local policeman), Tony Holt.

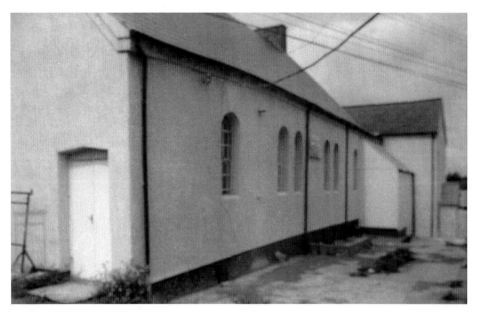

The former Congregational Chapel Sunday School in Lye High Street. The chapel was opened on 1 January 1821 but was replaced by a much larger building in 1827, known as Mount Zion. The building shown here was used not only as a Sunday School but also as a temporary Board School when the 1870 Education Act decreed education was to be available to all children until Orchard Lane Schools were built.

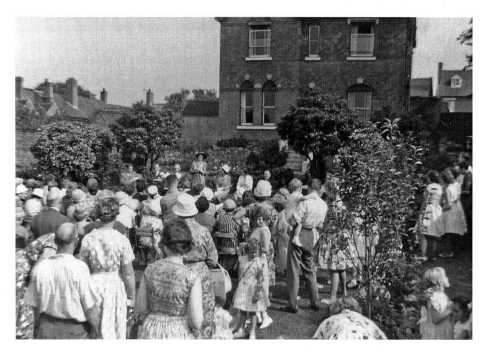

Lye Congregational Chapel lawn, 1959. Years ago the churches and chapels provided much of the social life of their members. Here is an example of a function arranged on a pleasant summer's day.

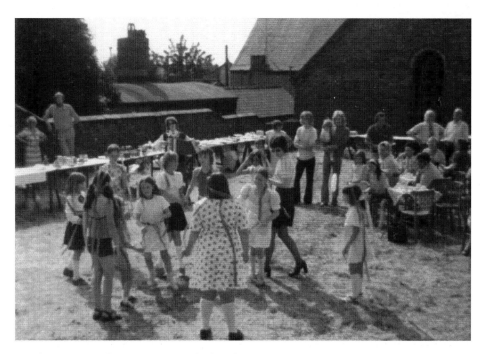

Another event at the Congregational Chapel, this time in the 1970s. Children are enjoying dancing to the music of an accordion.

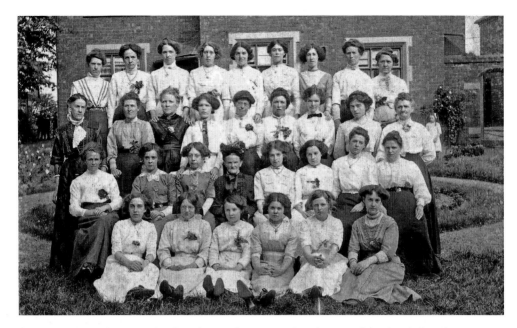

Hayes Lane Chapel, 1910. The chapel opened in 1896. This photograph is of its ladies choir in about 1910. There are thirty-two members seen here; singing seems to have been a popular pastime in Victorian and Edwardian times. Although none of the names of these ladies are given, they are interesting for showing female fashions of the period. The chapel closed in May 1975.

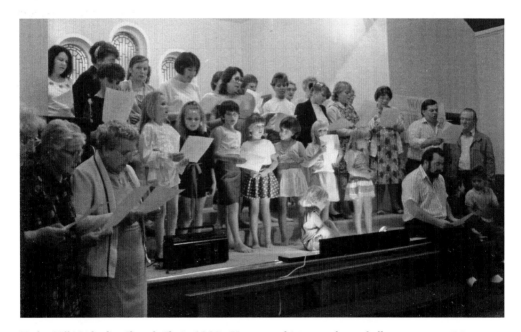

Hodge Hill Methodist Church Choir, 1980s. Here over thirty members of all ages are practising their singing. The chapel opened on 10 September 1938 and closed just over fifty years later to be replaced by housing.

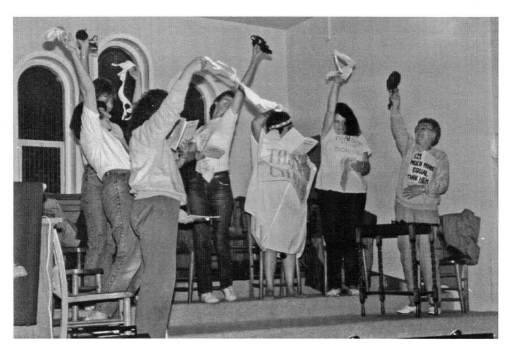

A more light-hearted view of Hodge Hill Church's Ladies Choir as they enthusiastically 'burn' their bras, no doubt influenced by the formidable feminist Germaine Greer.

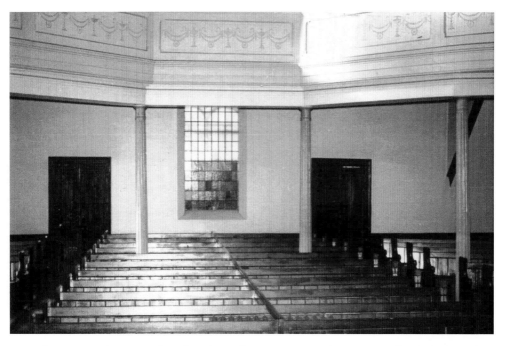

The interior of Mount Tabor Chapel in Talbot Street. Opened in 1872, it closed in 1964 when it was due to be demolished as part of the massive redevelopment of the area. This photograph was taken just before its closure.

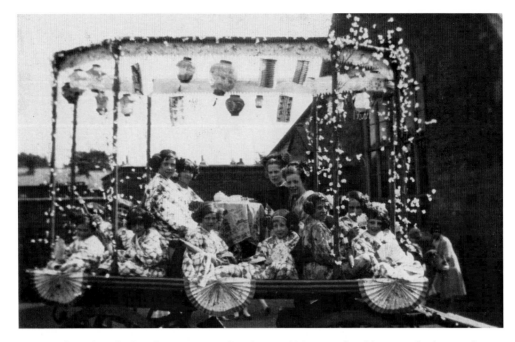

Mount Tabor Chapel's float for Lye Carnival in August 1928. Members' lives revolved around chapel activities, and here they are helping raise money for Corbett Hospital. They had enough support to enter more than this one float.

The view from the front of Mount Tabor Chapel shortly before its closure. Opposite are some of the shops which lined the street, all of which disappeared in the redevelopment.

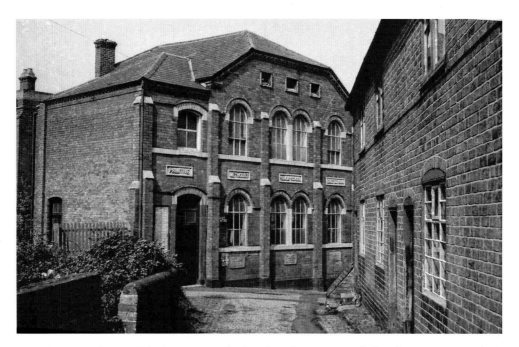

An external view of the Primitive Methodist Chapel in Love Lane before the tragic event which befell it in June 1974 (see below). Note the houses on the right; local clay would have been used for the bricks and iron for the window frames.

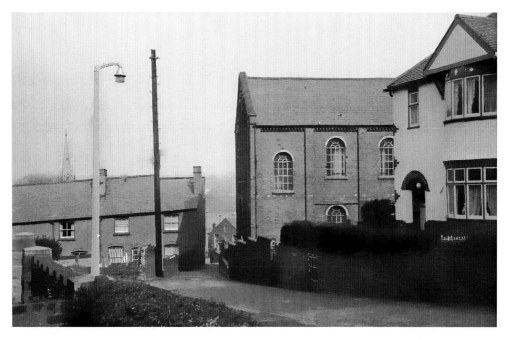

The Primitive Methodist Chapel was founded in 1831, with alterations in 1863. In the latter year it hosted a mission conducted by William Booth before he founded the Salvation Army. In June 1974 the building collapsed due to subsidence caused by nearby redevelopment.

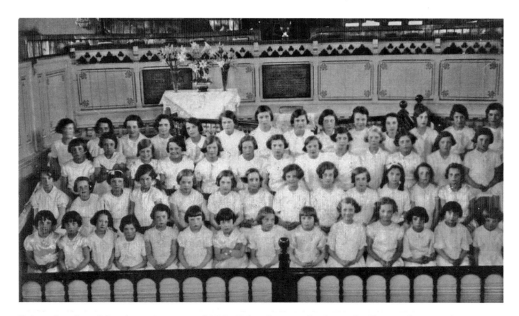

Prims Sunday School anniversary, 1936. Fifty-three girls dressed all in white ready to perform. It would have been a very important day for them. Back row, third from right is Mary Hazelwood; third row, third from right is Dawn Pearson; front row, fourth from left is Edith Watkins.

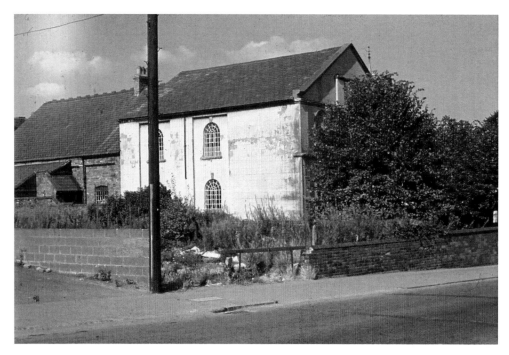

St John's Chapel shortly before demolition in 1968. Originally called the Wesleyan Chapel, Dark Lane (then a dirt track like many Lye roads), it was built on the site of an earlier chapel of 1837.

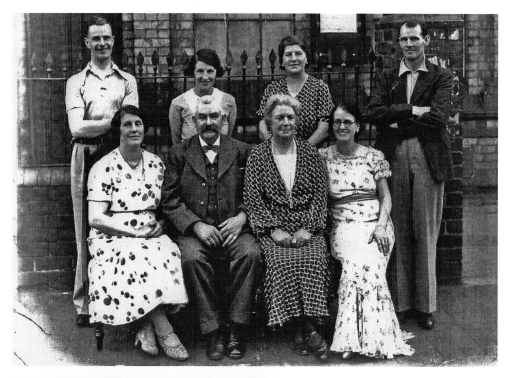

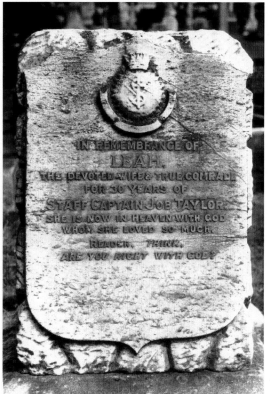

Above Salem Chapel group, late 1920s. The chapel was built in Pedmore Road in 1893. Mr George King Harrison donated 10,000 white bricks and his manager Owen Freeman designed it. Mr Benjamin Gauden, superintendent for many years, is shown here seated outside the chapel with his wife and children. He built a row of houses in Belmont Road, Wollescote, from one of which he ran a business selling furniture, while his wife had a grocery shop.

Left The tombstone of Leah, wife of Staff Captain Job Taylor of Lye Salvation Army. The Lye branch was established in 1881 and it immediately attracted many members. Its first citadel was built in Church Street in about 1900 but was demolished in the 1960s redevelopment and a new one built on the site of the 1840 National School in the High Street.

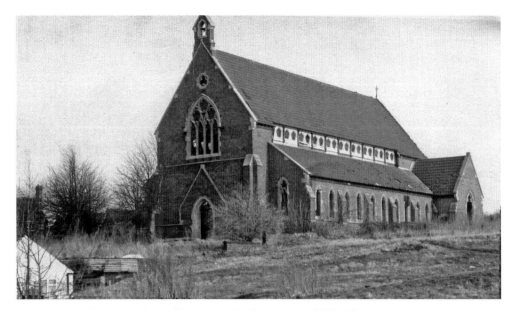

Stambermill Church shortly before its demolition in 1987. It opened in 1870 on land donated by local industrialist, Francis Rufford.

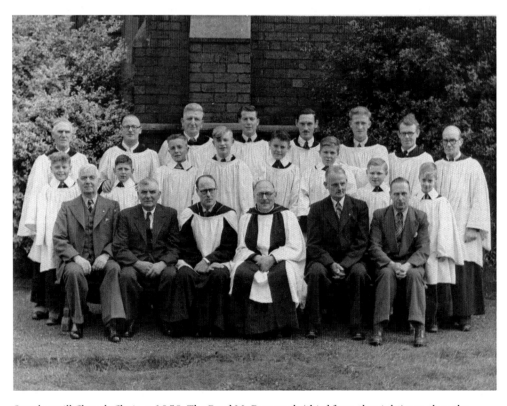

Stambermill Church Choir, *c.* 1950. The Revd Mr Burrough (third from the right) was then the incumbent.

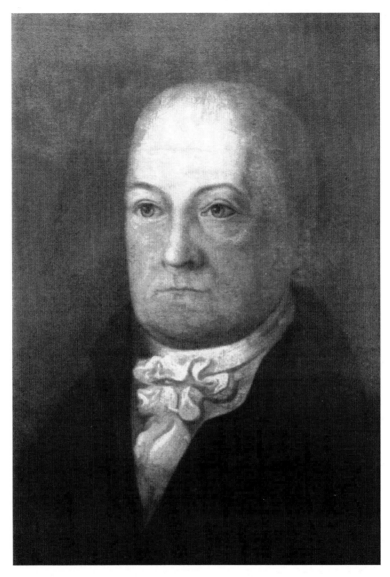

The Revd James Scott (1768–1828), Unitarian Minister of Netherend. The settlers on Lye Waste had long been regarded as lawless, so in 1790 he decided to hold a meeting on the Waste as a preliminary to 'civilising' them. He was so successful that the Lye Unitarian Chapel was opened in Upper High Street in June 1806 at a cost of £245 14s 9d. As the population increased so larger premises were needed, and in 1861 a new chapel was built on land adjoining the original one. It was designed by Francis Smallman Smith of Stourbridge and incorporated a tower with a clock in memory of the Revd Mr Scott. In 1953 the clock was replaced by an electric one to commemorate the coronation of Queen Elizabeth II. Unfortunately, this was stolen a few years ago in broad daylight. The chapel closed in 1991 and is now used for commercial purposes, but it is still remembered with affection as 'the village chapel'.

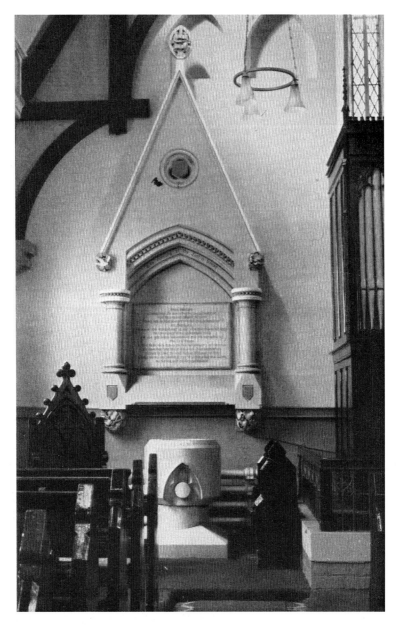

An interior view of the Unitarian Church showing the memorial to the Revd Mr Scott and the font. The chapel, although now used as business premises, was much vandalised before a buyer could be found, but thanks to the young Lye-born owner much of the interior has been preserved.

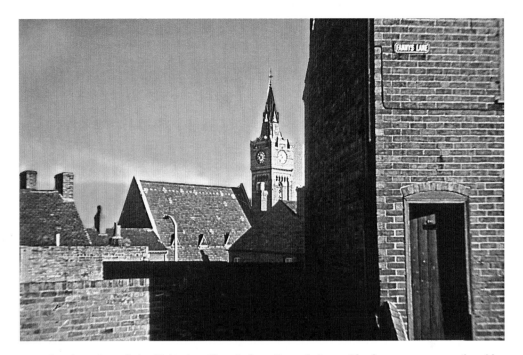

Another view of the Unitarian Chapel, from Fanny's Lane. The lane was among the older thoroughfares in Lye, all called lanes, probably because they were old dirt tracks. Tarred roads did not appear until the nineteenth century and the first Lye lane to be replaced was Dark Lane, probably as a result of the building of St John's Chapel. Note the old metal name plate.

A view of the Unitarian Chapel from Connop's Lane, 1960s. The whole area has a sad air of dereliction as redevelopment begins. This photograph shows the 1953 clock.

Unitarian Chapel, Lye

34 Stourbridge Road.
LYE,
Stourbridge
February, 1953

Dear Friend,

CLOCK AND TOWER APPEAL

To commemorate the Coronation of Queen Elizabeth II, the committee and congregation of the Unitarian Chapel are anxious to replace the obsolete clock in the tower by one which will add dignity to the building and be an amenity to the neighbourhood.

The present tower and clock were designed and constructed in commemoration of the Rev. James Scott, who conducted the first religious services in Lye and was the founder of the original chapel ("The Village Chapel") in the year 1790.

The clock has not worked for a number of years and many local people have expressed the hope that someday a clock in the tower will once more tell the hour of day.

Enquiries about the possibility of repairing it have not been encouraging, so the committee feel that a new one is the only solution.

The estimated cost will be about £450. As the congregation feel that the task of raising the whole amount is beyond their own unaided efforts, we invite your sympathetic consideration of this appeal, which is made with the sanction of the Trustees.

All donations or promises will be gratefully acknowledged on behalf of the congregation by:—

The Rev. LAWRENCE CHANDLER, B.A. (*Minister*)
 The Parsonage, Belmont Road, Wollescote
Mrs. D. GARDENER (*Treasurer*)
 15, Chapel Street, Lye
Miss G. GREEN (*Chairman*)
 Park Villa, Corser Street, Stourbridge
E. HILL (*Hon. Secretary*)
 Lutley Avenue, Halesowen
J. PERKINS (*Hon. Organiser*)
 34, Stourbridge Road, Lye

MINISTERS, 1790—1953	
JAMES SCOTT	1790-1827
WILLIAM BOWEN, M.A.	1828-1850
WILLIAM COCHRANE	1850-1866
JAMES KEDWARDS	1866-1877
THOMAS BENNETT BROADRICK	1877-1879
THOMAS PIPE	1880-1891
ISAAC WRIGLEY, B.A.	1891-1924
LOT HALL	1926-1927
JOHN WILLIAM DUMBLE	1929-1936
PHILIP CRABBE WHITEMAN, B.A.	1938-1950
LAWRENCE CHANDLER, B.A.	1951-

The appeal for donations toward the installation of a new electric clock, to commemorate the coronation in 1953, to replace the old one in the Unitarian Chapel tower.

56

4

CHILDHOOD

Lye Church (National) School was built in 1840 as an inexpensive way to educate children in basic subjects and the teachings of the Church of England. It later became the Church Hall when the government provided schools, and is now the site of the Salvation Army citadel.

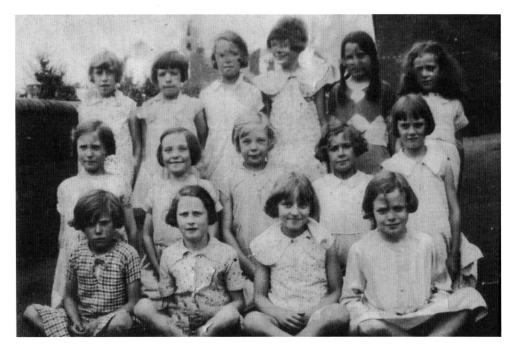

Lye Church School, situated on the corner of Vicarage Road, c. 1935. A small group of girls, all nicely dressed and with a variety of hairstyles – and also a wide range of facial expressions – pose for the camera. No doubt some were not used to facing a camera. Alice Chapman is on the extreme right of the front row.

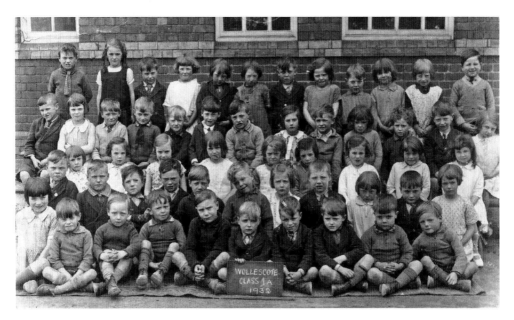

Wollescote Infants School, Class 1A, 1932. The school was built in 1897 to commemorate Queen Victoria's Diamond Jubilee. Still in use, it is now known as Drummond Road School.

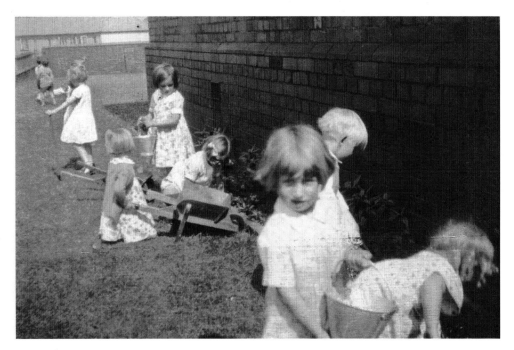

Pupils gardening in Wollescote Infants School grounds on a bright summer's day, *c.* 1935. The little girl facing the camera is Dora (Dodo) Stinton. The school was ahead of its time – classrooms had wall displays, toys to play with, concerts for parents to watch and Christmas parties with presents.

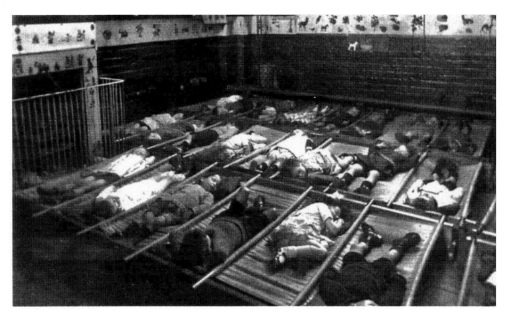

Rest time at Wollescote Infants School, 1930s. A nap in the afternoon was part of the school day for the very young, as was the cleaning of teeth with Gibbs' toothpaste in a tin with a Disney-style castle on the lid.

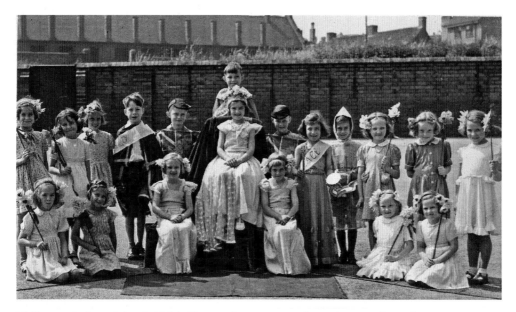

Wollescote Infants School, 1954. The pupils are posing for a photograph in the costumes of a play they had performed. Arlen Pardoe (fourth from the left) wears a sash for loyalty. The hooded boy is Major Robins. Local parents liked important-sounding names for their offspring – such as Major, Sergeant, etc. The wall behind the group divided the boys' and girls' playgrounds, so this was a rare occasion for the boys as the photograph was taken in the girls' playground.

Crabbe Street Board School opened on 9 October 1882 as a result of the 1870 Education Act decreeing education for all. Built by W.H. Jones of Brook Street, Lye, it cost £1,368. There were three departments – boys, girls and infants. Major Pardoe was appointed head at the age of twenty-three.

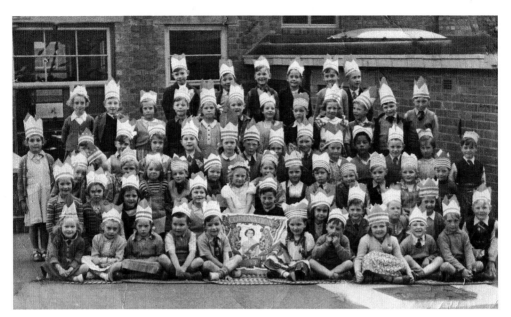

Cemetery Road Infants School on the occasion of Queen Elizabeth II's coronation, 1953. An infants-only school, it opened in 1882 and was always known as the Little School. Back row, left to right: -?-, Robert Hingley, Gary Cooper, John Hunt, Martin Mobberley, Peter Webb. Fifth row: Christine Farmer, David Bottomley, Carol Bedford, -?-, Marion Hipkiss, Graham Heathcote, Sandra Matthews, -?-, Barbara Bache, Van Griffin, Trevor Brettle, Alan Walters. Fourth row: -?-, David Wooldridge, Jennifer Wilson, David Upton, Yvonne Wooldridge, John Evans, Jennifer Cooper, Ronald Williams, Margaret Hopkins, Tony Green, John Hill, Denise Pavlovitch. Third row: Barbara Bangham, -?-, -?-, Glynn Watts, Rosemary Mountford, -?-, Celia Little, -?-, Carol Cooksey, -?-, John Barrett, Mavis Huxley, -?-, Susan Homer, -?-, Tony Corfield. Second row: Sandra Higgins, Gillian Dunn, Norma Smith, Victoria Shaw, Angela Bingham, Terence Cartwright, Christine Edwards, Ronald Millward, Susan Pope, Christine Hyde, -?-. Front row: Margaret Crompton, Diane Perry, Susan Goodman, Anthony Cadman, Stuart Taylor, -?-, Graham Taylor, Susan Cogzell, John Newey, Cedric Leedham. The headmistress at this time was Miss M. E. Lewis and the teachers were Miss Weeksm Miss Bayliss, and later, Mrs Digger.

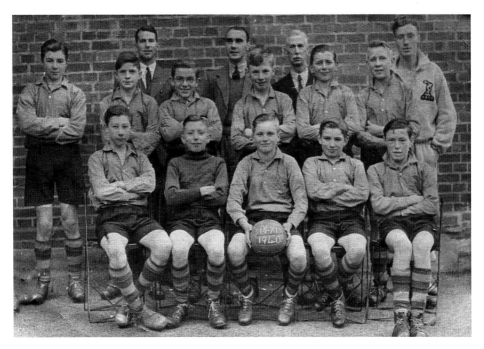

Grange School football team, 1940. The school was built in 1939 to serve the fringe of the town. The headmaster was Mr John Wooldridge, who had previously been head of Orchard Lane Boys' School in 1918. He was a local councillor and one-time Major of Stourbridge. His sister, Amy, was head of an infants school in Evesham and was the town's first female councillor, alderman and mayor.

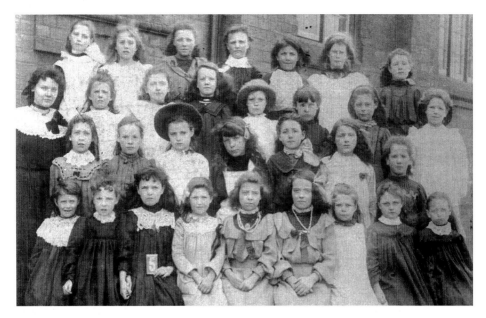

Class 5 of Orchard Lane Girls' School, 1904. Although no names are available, the photograph is useful in showing dress and hairstyle fashions of the time. The teacher is on the extreme left.

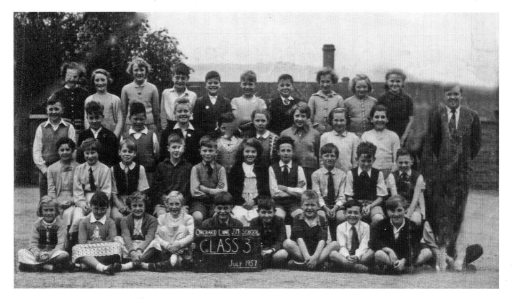

Orchard Lane Junior Mixed School, Class 3, July 1957. Class numbers were higher then – there are thirty-eight children pictured. Male teachers were becoming more common after the war.

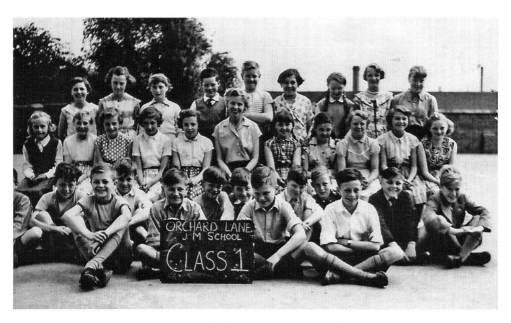

Orchard Lane Junior Mixed School, Class 1, 18 July 1958. The idea of school uniform is still in the future. Back row, left to right: Jennifer Goulding, Margaret Hopkins, Marlene Ferguson, Geoffrey Hart, Alan Rollinson, Barbara Bangham, Yvonne Wooldridge, Lorraine Morgan, Mary Holloway. Third row: Patricia Walker, Anglea Bingham, Josephine Bridges, Sandra Higgins, Joyce Berry, Mrs Simmonds, Beverley Heaven, Norma Smith, Susan Pope, Christine Hyde, Lesley Knott. Second row: David Worton?, Melvyn Willetts, Derek Hill, Geoffrey Leadbetter, Stephen Evans, Kenneth Forest, Graham Blunt, Robert Watkins, Cedric Reed. Front row: John Cross, Roger Darby, Clive Robbins, Terence Cartwright.

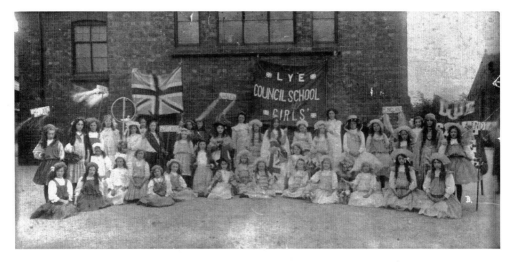

Valley Road Council School, *c.* 1911. The school was opened in 1911, mainly through the pressure of the Unitarian Minister, the Revd Mr Wrigley, on Worcestershire County Council to provide a school for older pupils previously taught at Orchard Lane. These girls are possibly celebrating Empire Day.

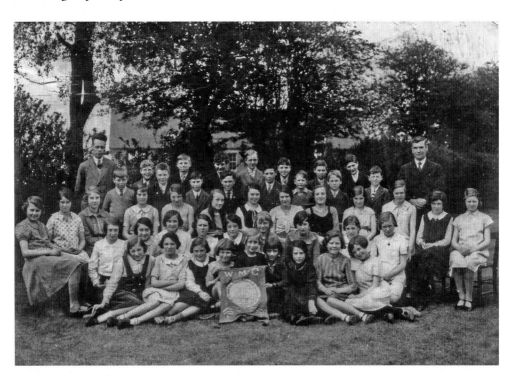

A group of pupils and staff of Valley Road Council School, 1936. The headmaster, Mr Harper, is on the far right and the male teacher on the left is Mr Crook, who taught music and PE. The significance of the banner is unknown.

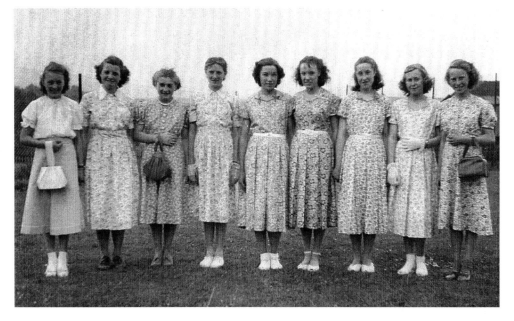

Valley Road School, Mrs Deeley's sewing class, 1951. Mrs Deeley was an excellent needlework teacher and her pupils modelled garments they had made at parents' evenings. Left to right: Margaret Mobberley, Barbara Wilkes, June Genare?, Mary Green, Pat Reece, Betty Wooldridge, Iris Butler, Diana Williams and Winifred Davies.

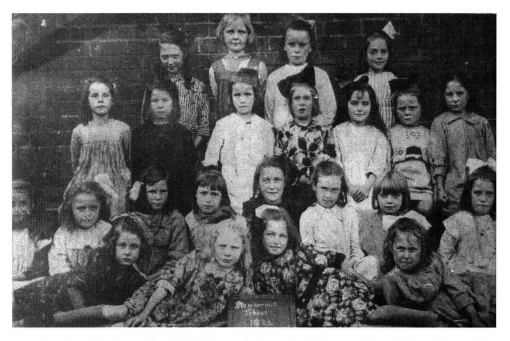

Stambermill Infants School, 1921. It was built in the 1850s as a Church School through the efforts of Lye Vicar, the Revd Mr Bromley. None of the children have been identified.

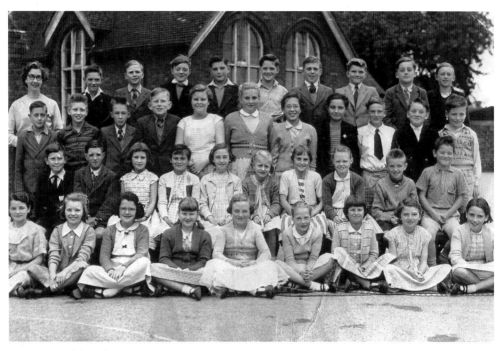

Above Stambermill School, 1957/8. Back row, left to right: Mrs Jasper, Eric McDonald, Gyn Watts, John Cooper, Gilbert ?, John Cox, Philip Whittaker, Roger Porter, -?-, Charles Mayor. Third row: -?-, -?-, Timothy Hazordine, Gary Tolley, Wendy Stevens, Barbara ?, Joan ?, -?-, Robert Skelding, Ashley Dodd, Kevin ?. Second row: Michael ?, -?-, Pamela Walton, Maureen Carpenter, Marlene Stokes, Shirley Wooldridge, Barbara Burford, Maureen Schofield, John Taylor, Anthony Garrington. Front row: Celia Little, Gwyn Cross, -?-, Heather King, Katherine Allcock, Jean Taylor, Jean Petford, Gloria Wood, Pamela ?.

Left A childhood portrait of Sir Cedric Hardwicke. He was born in Lye Cross House in 1893 and was the son of a doctor. From a very early age he showed a talent for acting, becoming an internationally famous film star. He died in America in 1964. His birthplace, a Queen Anne house, was demolished a few years later.

Percy Scard, 7 November 1897, photographed in William Pardoe's studio in Vicarage Road. The Scards were a travelling family associated with Pat Collins' fair. They had a moving picture show months before the Lumière Brothers in Paris, who have always been regarded as the inventors. The photograph was sent with love and kisses to his grandma in Portsmouth.

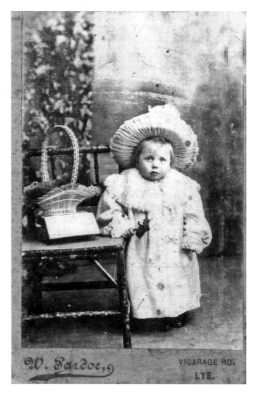

Harry and Florrie Scard – a photograph taken by William Pardoe at the same time as Percy's.

Norman Burford and sister Lily, *c.* 1917. Lily worked at J.T. Worton's large drapery shop in Lye High Street. Mr Worton was a prominent local figure representing Lye on Worcestershire County Council for many years, along with other public duties. Sadly, Lily died of tuberculosis at a young age. It was quite a common ailment in those days.

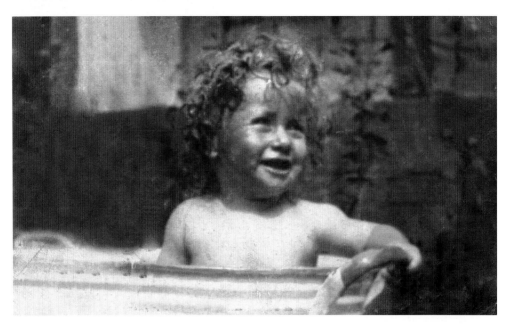

Bath time, 1932. Happy two-year-old Dora Stinton in the Lye-made tin bath. The family were then living in Coppice Avenue, Wollescote. Sadly, she died of meningitis in 1946. A radio appeal for penicillin remained unanswered due to the amounts required for servicemen and people in Europe.

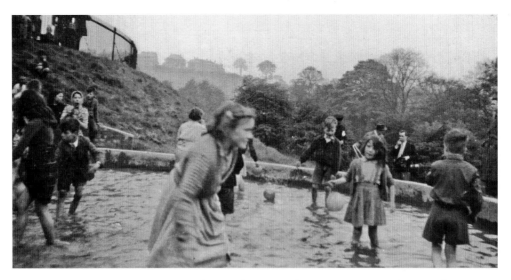

The opening of the paddling pool in Wollescote Park, *c.* 1949. A press photographer may be seen on the right-hand side and possibly the park keeper alongside him. This pool replaced the original provided by Ernest Stevens in 1932.

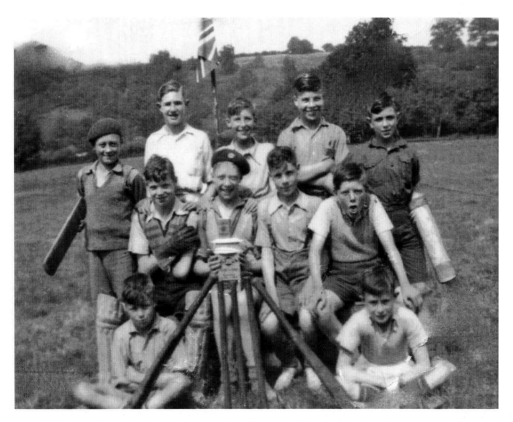

Wollescote lads enjoying a game of cricket, *c.* 1932. In spite of huge council housing development, the area still had plenty of open space in which children could play.

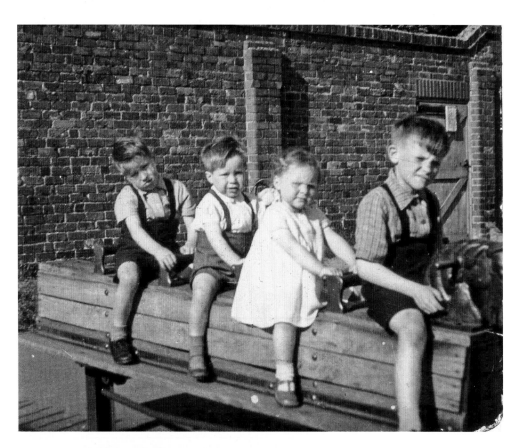

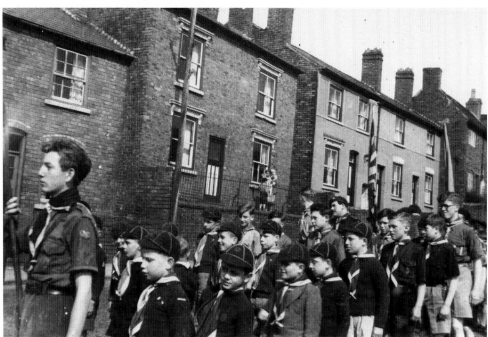

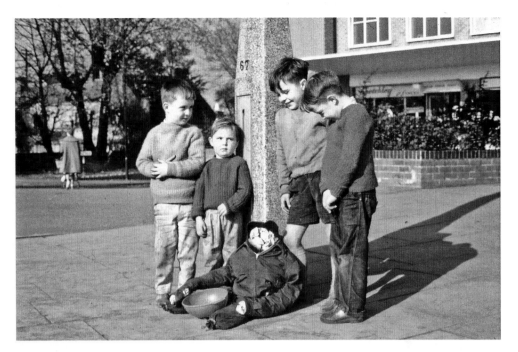

A delightful picture captured in July 1968 – rather early to be collecting for Guy Fawkes' night! To the left Cedric Hardwicke's birthplace still stands but was later demolished for road improvement. Modern shops replace the Victorian Rose & Crown public house behind the boys. Fortunately nowadays the whole of the High Street is a conservation area.

Opposite, from top
Children enjoying a ride in Wollescote Park's children's play area in 1948. On 5 November 1932 the local council opened a children's play area, parallel to the football ground in Stourbridge Road, Lye, for those who might find the walk to Wollescote Park too tiring.

Primitive Methodist Chapel Cubs and Scouts marching down Cemetery Road, *c.* 1950. The tall boy on the right is John Smith, two places in front of him is Gary Homer, and on his right is Alan Whitehouse. In front of him are Arlen and Daryl Pardoe. Donald Richards, wearing the beret, is in charge.

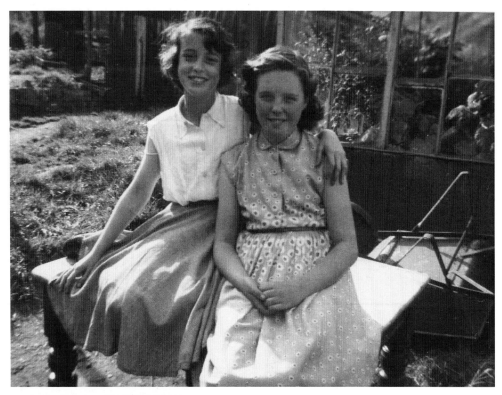

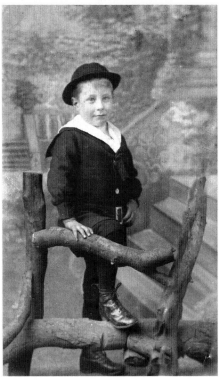

Above Christine Dainty (left) and her friend Janet Wooldridge sitting in the garden in 1954. Behind them still stands the wartime Anderson shelter, a flat pack provided by the government to be erected in everyone's garden in the Second World War. An indoor version, the Morrison shelter, which resembled a huge, table-high cage, was available for those without a garden.

Left Young Bill Pardoe, the son of Lye photographer William Pardoe, photographed in his fathers' studio. He was born in 1904.

5

WORK

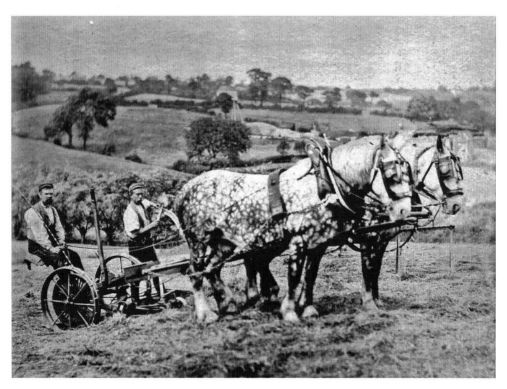

Haymaking, *c.* 1898. A William Pardoe photograph taken at one of the local farms, of which there were six in the Wollescote area then. It is possible that this picture was taken at Hob Green Farm.

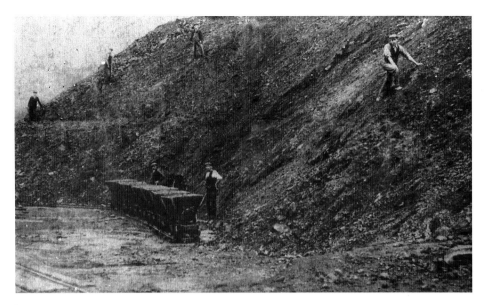

The Lye and Wollescote area was famed for its fireclay, said to have been discovered by seventeenth-century Huguenot refugees digging tent peg holes in Hungary Hill, Stambermill. As glassmakers they realised its value in its manufacture. It also led to a large brickmaking industry. The clay was extracted from pits and marl holes. This 1920s or 1930s photograph shows 30,000 tons of fireclay raised from the Oldnall and Beech Tree collieries.

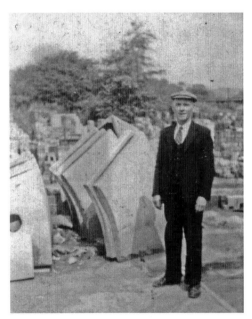

Left Harold Kendrick, manager of Timmis's brickworks in Stambermill. Among other products, Timmis's made retorts for gas works, some of which may be seen behind him.

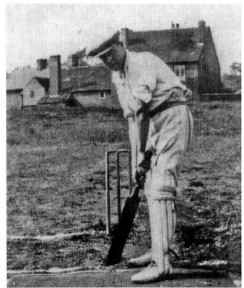

Right Timmis's had a cricket pitch behind the factory in the 1930s. It boasted the first concrete wicket in the Midlands. Here we see Bill Tolley at the crease.

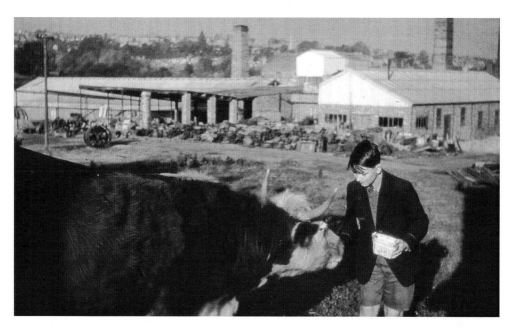

Hadcroft Brickworks, Grange Lane, 1950s. The raw material for the bricks was plentiful in the area and was extracted from nearby marl holes. This photograph not only shows the works, but also young Jeremy Smith feeding a cow from the adjacent farm. Both the works and the farm have been replaced by vast housing developments.

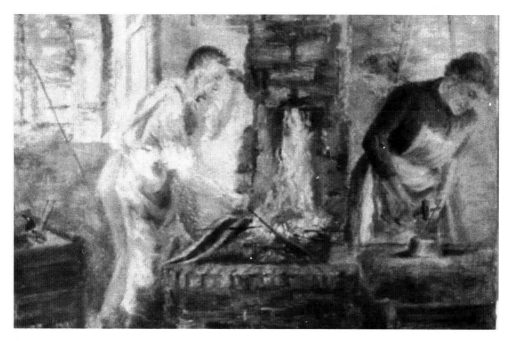

A nineteenth-century drawing of a nailshop. For centuries nailmaking was largely a domestic industry in Lye with a nailshop attached to the house. This sketch was sent to the late Denys Brooks from New Zealand settlers.

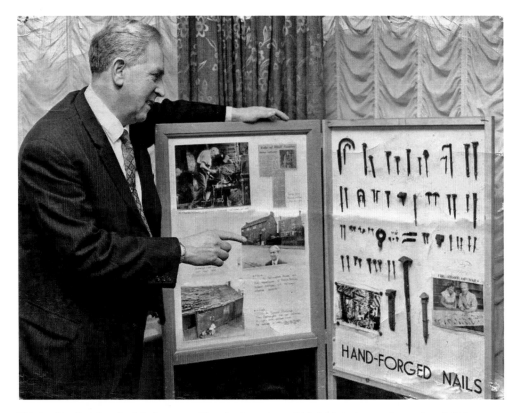

Wesley Perrins, local celebrity, councillor, trade union official, historian and one time MP for Yardley, spent his retirement visiting schools and groups to talk about Lye industries. Here he is shown with a display to illustrate the variety of products in the nailmaking industry.

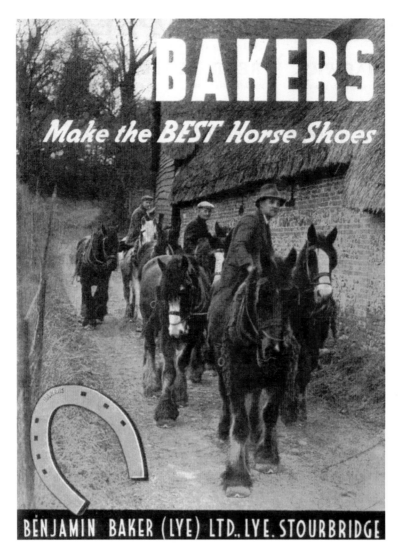

A mid-1950s advert for Baker's horse shoes in the *Farriers Journal*. Ben started the works in 1887 in King Street in property resembling housing – easily converted back if the business failed. However, over time it became a world-famous concern, producing over 800 types of horse shoes. It closed down when the recession struck but has now been restarted.

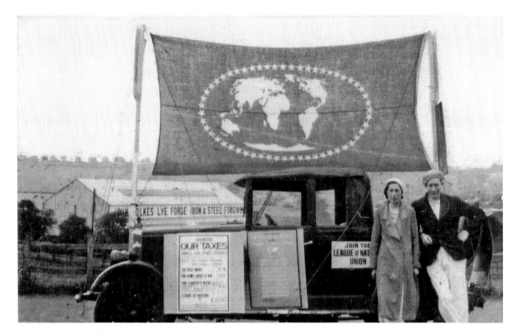

A picture taken for the 1934 Lye Carnival but printed here because no other picture of Lye Forge was available. It may be seen in the background and the logo reads 'Folkes Lye Forge Iron & Sheet Forging'. Founded in Dudley Road in 1699 by Joseph Foulkes, one of a long line of blacksmiths, it used water power at first but later used steam. It is still in business today.

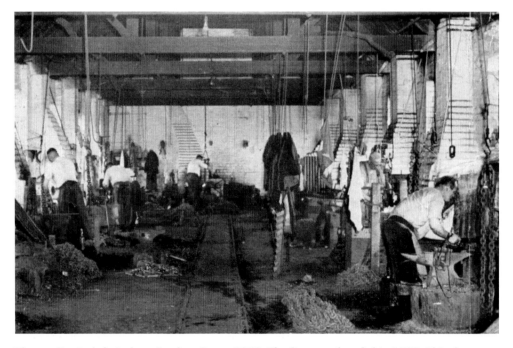

Thomas Perrins' chainshop, Careless Green, 1958. The firm was founded in 1770. This shot shows its furnaces and chainsmiths at work on their anvils.

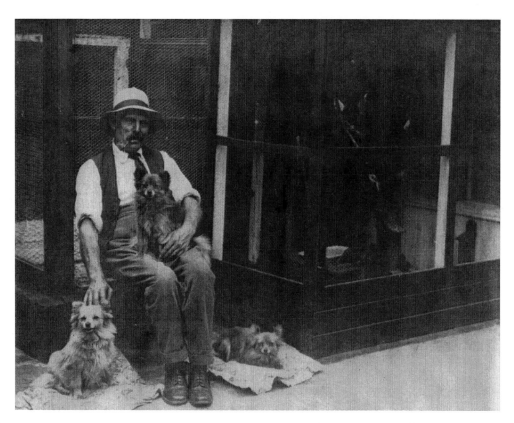

Above Mr Pearson, obviously a pet lover with his birds and dogs, caught on camera in the 1930s. He was employed at Higgins & Sons Regency Works, Lye. The firm produced heavy industrial machinery and Mr Pearson worked on the manufacture of presses, one of which is in Churchill Forge – a ladle-making press.

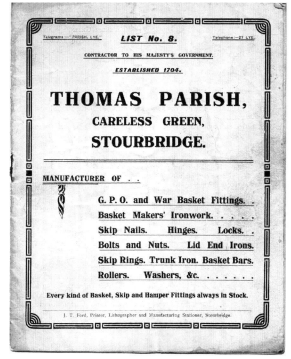

Left An advert for Thomas Parish of Careless Green. The firm was founded in 1704, supplying equipment to the government in the early 1900s, particularly during the First World War.

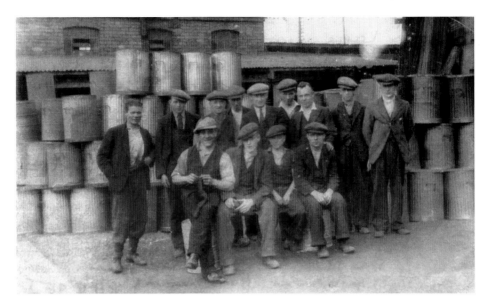

J. & P. Round's hollow-ware factory, 1933. The first factory was in Orchard Lane, but this photograph was taken in Engine Lane when the firm expanded by taking over the premises of Thomas Hill. Back row, left to right: B. Billingham, N. Gray, E. Connop, A. Hyde, H, Maybury, H. Foley, L. Griffith, J. Griffiths, J. Skidmore. Front row: B. Hill, A. Granger, W. Knowles, Jack ?. Note the dustbins in the background, which were exported all over the world and supplied to many British councils, including Belfast, Birmingham, Birkenhead and Blackpool, to name but a few.

A page from an exercise book recording the wages of J. & P. Round's workers in Orchard Lane, 1902. The Rounds allowed Wilson's Fair to come to the field adjacent to the factory where the firm's horses were kept. Fred Higgins bought the horse manure for 2d a dobbin for use in metal castings.

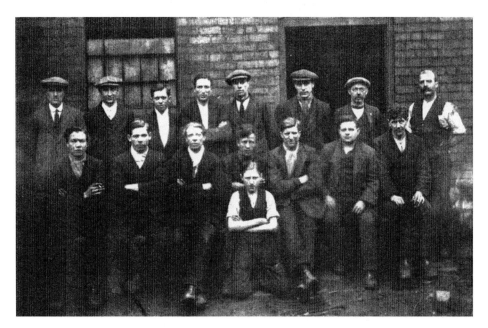

J. Croft, Pearson Street, Lye, hollow-ware manufacturer, 1920s. Back row, first left is Mr Warren and second left is H. Jackson, the manager. As Mr Warren is very smartly dressed like Mr Jackson, presumably they are not part of the regular workforce?

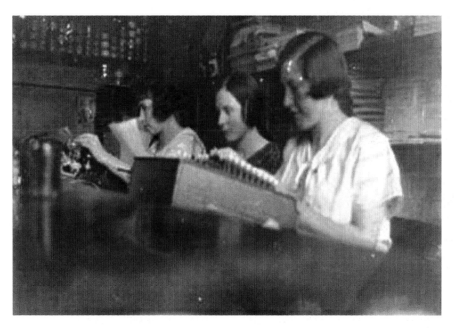

Eveson's office staff, 1920s. The two Eveson brothers started their career making steel trunks in a tiny workplace in Union Passage, Lye, in the 1890s. They then moved to Balds Lane making galvanised and enamelled hollow-ware. Later they moved to Rhodes' factory in Providence Street. A family member also had a small factory in Vicarage Road making electrical goods.

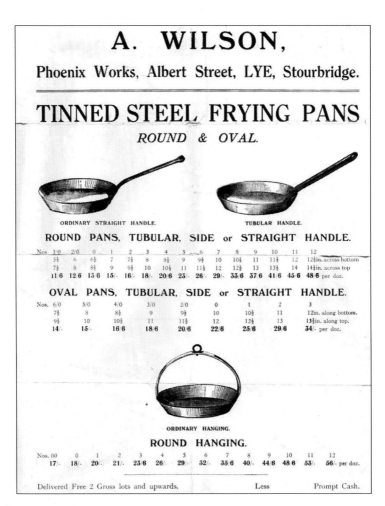

Advert of A. Wilson, Albert Street, Lye, manufacturer of various forms of frying pans in the early 1900s. He had found a special niche in the hollow-ware trade but would probably have lost out when enamelling was introduced.

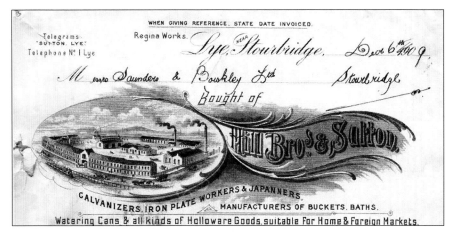

A receipt for buckets from Hill Brothers of Regina Works (whose telephone number was Lye 1), 1901. The receipt shows an idealised sketch of the factory.

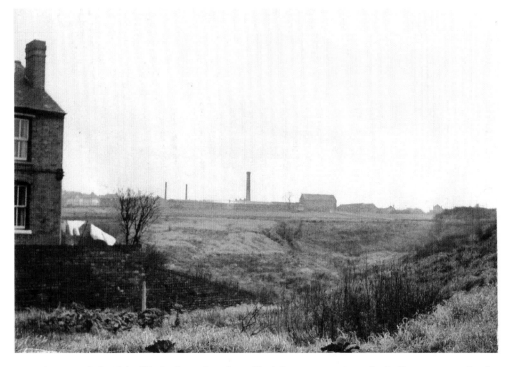

A view of the Tala Works from Stambermill. A late entrant into the hollow-ware trade, the factory is still famed for its kitchenware products. The photograph was taken before the development of the area around Grange Lane in the 1960s.

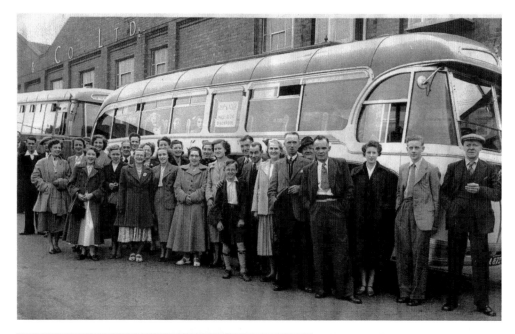

Above Hingley & Lamb annual outing to Blackpool, 1951. The factory in Stourvale Road (but then called Railway Street) made a variety of hollow-ware goods, but like the other firms in the trade suffered from the introduction of plastic.

Left Mabel Hamblin lived in Wassell Road, Wollescote. She had polio as a child but found work as a tailoress in Lavenders, the quality tailor's shop in Lye High Street. When it ceased trading she set up her own business. Also a great gardener, she won many awards in horticultural competitions.

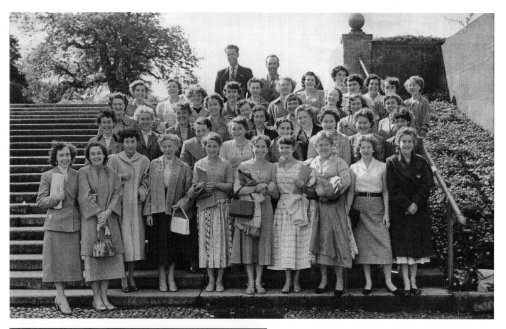

Above Valley Products, Valley Road, Lye. This produced garments mainly for women and most of the employees were female. It had a happy working atmosphere with outings and social events, but cheap imports from abroad led to its closure.

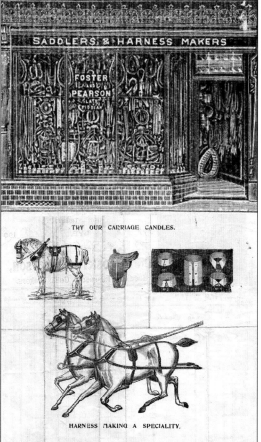

SADDLERS & HARNESS MAKERS

FOSTER PEARSON

TRY OUR CARRIAGE CANDLES.

HARNESS MAKING A SPECIALITY.

Left Foster & Pearson, saddlers, harness and collar makers, operated in Lye High Street at the turn of the twentieth century. In those days they would have had plenty of custom as the motor car would still have been a very rare form of transport, so factories and shops would have used horse-drawn vehicles in their businesses.

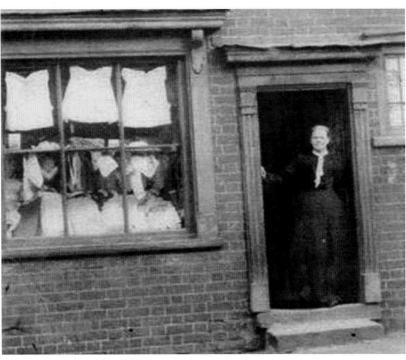

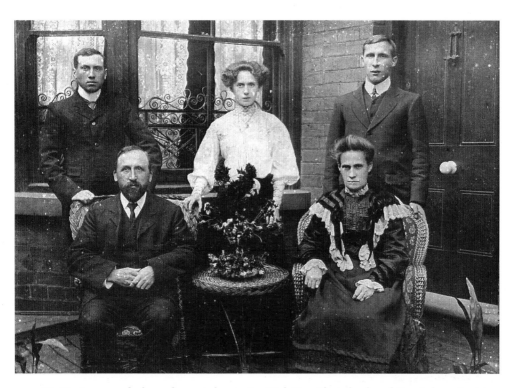

Mr Worton owned a large drapery shop in Lye High Street but also found time to be a chorister, a local councillor and philanthropist. Here he is shown with his wife, Sarah, and children, Harry, Kate and Fred.

Opposite, from top
Mrs Suzy Guest opened her shop selling wool, babywear and school uniforms in Lye High Street in 1924. The interior, with its mahogany counter and wooden panelling, never altered but the exterior changed over time. The photographs show Suzy and her daughter, Margaret, in the shop in 1956, and the shop exterior in the 1960s and 1996.

The Talbot Street shop of Eliza Prangnell (1844–1914). It was a baby linen shop which she opened at the turn of the twentieth century when she moved from Birmingham to be near her nephew in Stourbridge.

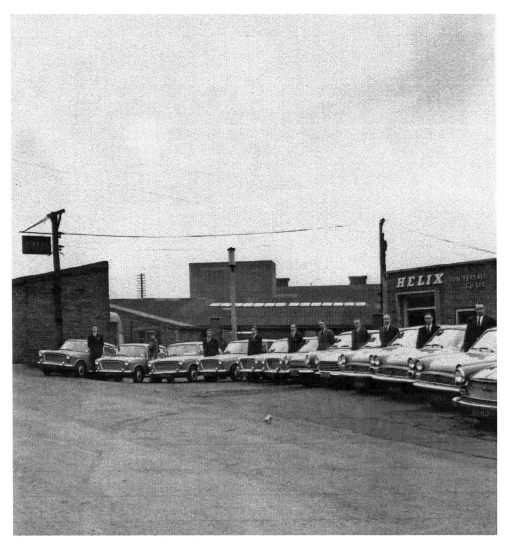

Helix workforce photographed in front of the original factory entrance in Engine Lane, 1960. Seen here are the travelling salesmen with their new cars. On the right is Mr Peter Lawson, chairman from 1968 to 1995. The firm started in 1887 making wooden rulers and laboratory equipment. It moved to Lye in 1955, by then adding more and more items such as compasses, maths sets and rubbers. Diana, Princess of Wales attended its centenary celebrations.

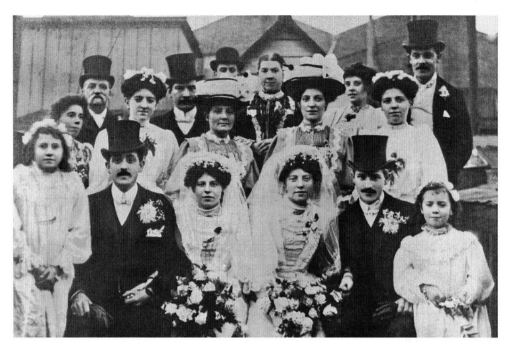

Pickrell wedding, 3 January 1908. Two brothers married two sisters at Deptford in London, to where the Pickrell family had moved from Lye to find work.

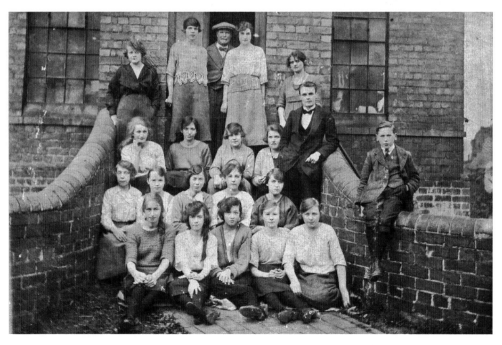

Elisha Cartwright's workforce seated outside his clothing factory. It was situated behind the Centre Buildings which housed his shop and was the first place to have electric lighting in Lye. Cissie Tomkins is on the front right in this photograph from about 1912.

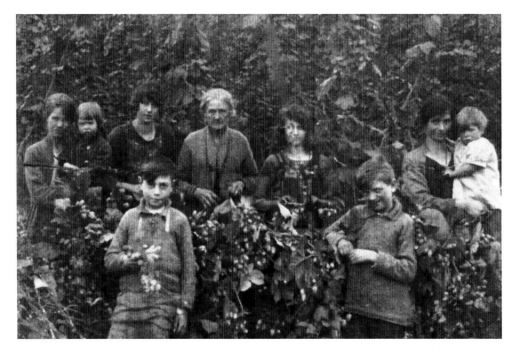

Hop pickers, 1930s. The only change of scenery many Lye people enjoyed was when they went hop picking to Herefordshire and Worcestershire farms. Although they had to work hard, they regarded it as a holiday. The wives would be there full-time while the husbands visited at weekends. Schoolchildren were allowed two weeks' absence from the classroom. Back row, first left is 'Auntie Floss', who is holding little Roma. Mrs Hart is next to her and Roma's grandmother 'Grannie Bedford' is beside her.

6

LEISURE

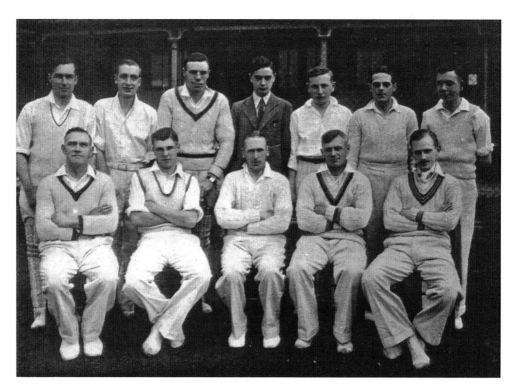

Lye Thursday cricket team, 1930s. This was a team composed of Lye businessmen, many of whom were shopkeepers. The photograph was taken in front of the cricket pavilion on the sports ground in Stourbridge Road. Back row, left to right: Wilf Hill, George Pardoe, Dick Price, Vernon Hart, A. Cartwright, G. Noake, G. Packwood. Front row: S.J. Wyre, (guest), Fred Smith, J. Perkins, John Bridgwater.

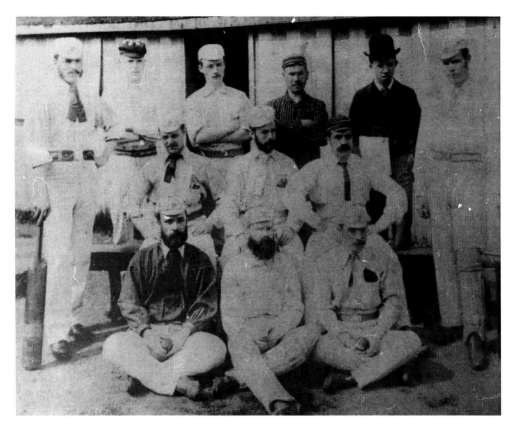

Victorian Lye cricketers photographed in front of the cricket pavilion. Note the different styles of headgear.

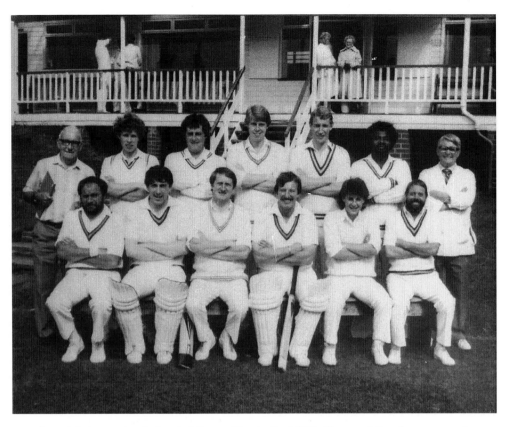

Lye cricketers posing in front of the pavilion in the 1970s. Names of the players are unknown as records were destroyed when the pavilion burnt down.

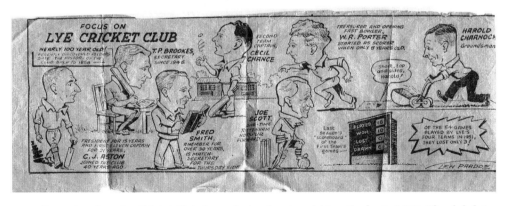

Characters from Lye Cricket Club drawn by local cartoonist Len Pardoe in 1951. The club dates from the mid-nineteenth century. Unfortunately, a fire destroyed many records of the cricket club and the football club a few years ago.

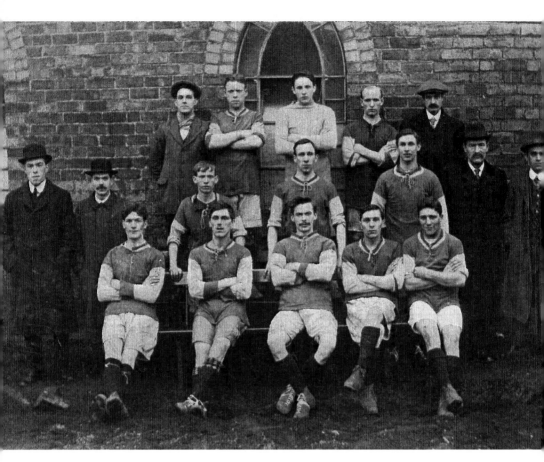

Bethel football team photographed sometime before 1914 in front of the original chapel building, which has now been greatly extended. Back row, left to right: Harold Dickens, Ben Phillips, Will Share, -?-, Will Newey. Middle row: Tom Knowles, B. Gordon, W. Dunn, G. Share, Harry Smith, Amos Perrins, S. Barnbrook. Front row: Harry Hill, Isaiah Moss, Ted Perks, Dick Moss, Will Partridge. Most chapels and churches in Lye had football teams to encourage young men to attend services.

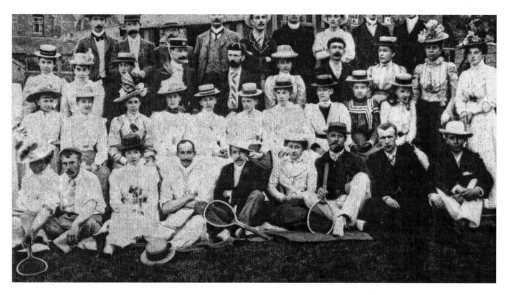

Lye Tennis Club, photographed in 1908. It is difficult to imagine some of the ladies playing in those dresses and hats. The school in the background is Orchard Lane Board School, opened as a result of the 1872 Education Act.

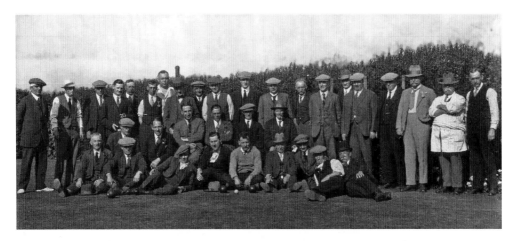

Lye Bowling Club, 1921. Bowling was a very popular Lye sport. Unfortunately, no names are available for those in the photograph, nor the venue. Experts might work the latter out by identifying the factory chimney. The umpire looks a force to be reckoned with!

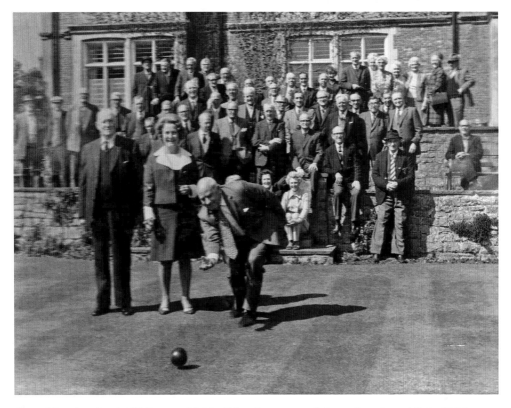

Sons of Rest bowling in Wollescote, 1960s. When he presented the park to the public in 1932, Ernest Stevens gave rooms in Wollescote Hall to the Sons of Rest, only a few yards from the Bowling Green. Here Mr Morgan, their president, and his wife attend a match. Wesley Perrins is on the extreme left of the third row of spectators.

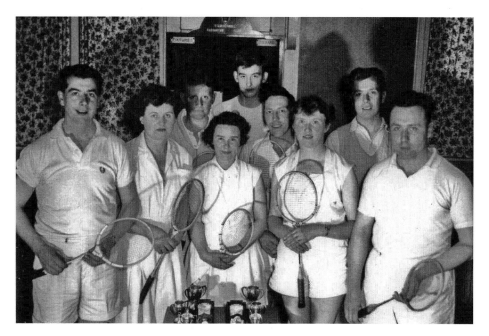

Badminton team, St Mark's Church, Stambermill, 1955. The club started in 1938 as part of the Cradley Heath and District Badminton League. Second from the left in the front row is Lillian Nash. First left in the second row is Eric Nash.

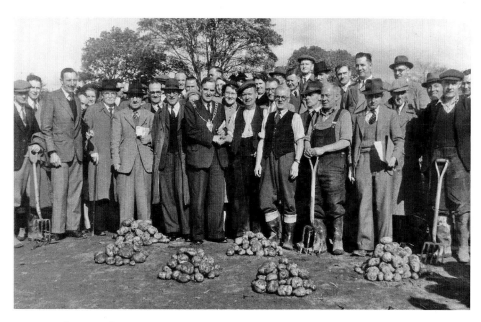

Lye & Wollescote allotment holders' potato competition, 1950/51 season. Mr Joyner, park superintendent who checked the weights, is on the left-hand end of the second row. Miss Moody, who presented the prizes, is to the right of the mayor, Cllr Gregory. Her brother (in the spectacles) is on her right. Frank Dickens is second from the right of the mayor and Arnold Stevens is fourth from the left on the second row.

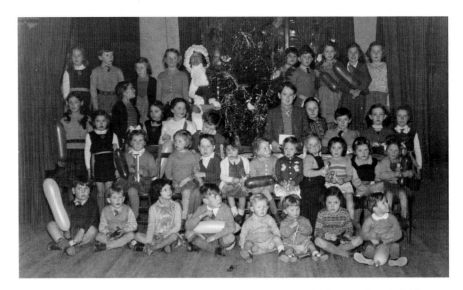

Lye Health & Beauty Christmas party, *c.* 1949. This was held for members' children in the old Church Hall (formerly the Old Church School building of 1840). Darroll Pardoe is seated in front of Santa and his brother Arlen is in front of him.

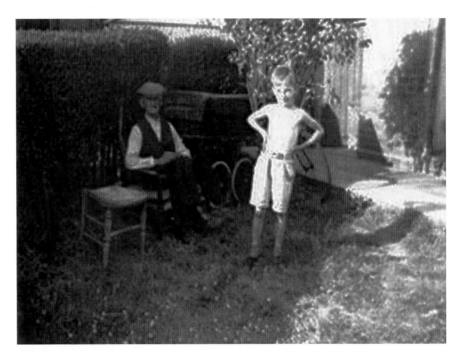

Mr Watkins and his great-grandson, Kenneth, enjoying the sunshine. Beside Mr Watkins, who together with his son, was a well-known, successful pigeon fancier, is the old pram in which they transported baskets of pigeons.

Mr Watkins Jnr was a great angler and never went anywhere without a piece of wire and a hook in his pocket.

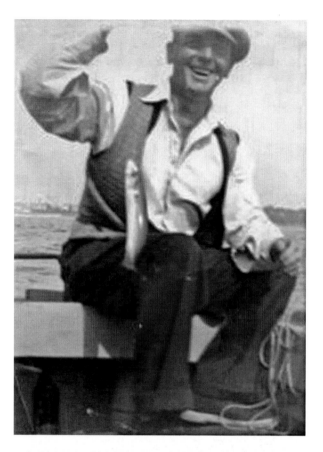

Lye Traders annual outing to Church Stretton, 1935. Third from the right on the back row is John Tye Forest Homer who had an ironmonger's shop at the bottom end of Lye High Street.

Mount Tabor Chapel outing, 1960s. Left to right: Mrs Heathcote, Margaret Lucas, Mary Jones, Verity Farmer, Lily Lucas and Winnie Wooldridge. It is worth noting here the importance of the Lye churches and chapels in the lives of members. As well as the religious aspect, they provided education, entertainment, experience in organisation, public speaking and social contacts. Many members went on to become leading figures in the community and some of national significance.

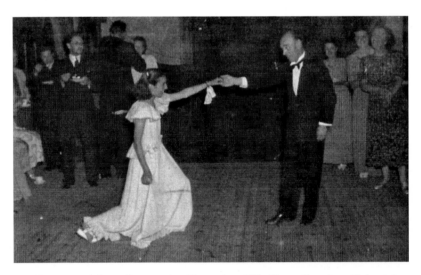

Mr Horton and his wife ran the Hortonian Olde Tyme Dancing Club at Lye Conservative Club Assembly Hall for many years. It met every Wednesday evening from 7.30 to 11 p.m. at a cost of 1s 6d. Here Mr Horton and his daughter Angela demonstrate a dance. Sadly, Angela died on 15 October 1952 at the age of just sixteen.

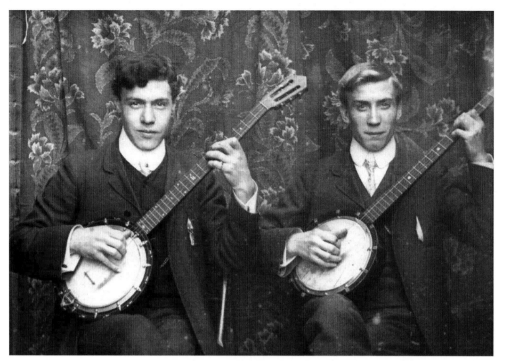

Above Banjo players, 1907. On the left is Bob Brettell and to the right is R.H. Mallen who sadly died at the age of twenty-two. Lye produced successful musicians, singers, actors, writers, inventors and public figures but seems to get little recognition for it.

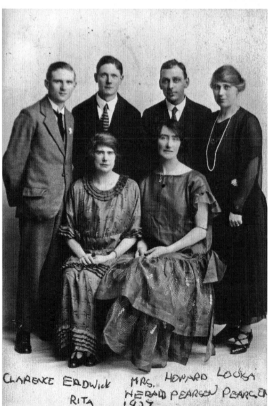

CLARENCE ERDWICK MRS. HOWARD LOUISA
RITA HERALD PEARSON PEARSON
1927

Left In the early 1900s Mrs Herald, along with an enthusiastic committee of supporters, produced Shakespeare plays such as *A Midsummer Night's Dream*. The committee, seen here, are, back row, left to right: Clarence Chance (accompanist), Erdwick Bellamy (lighting), Louisa Pearson (treasurer). Front row: Rita Bellamy (costume) and Mrs Herald (stage manager).

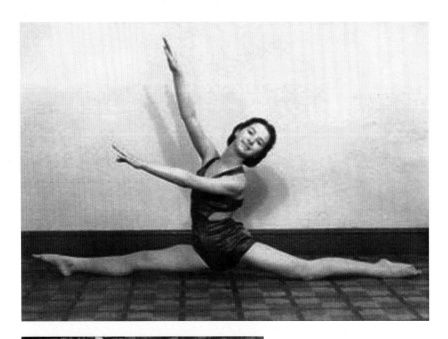

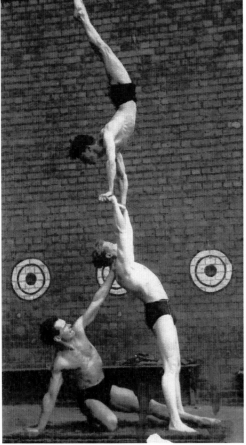

Above Hazel Stanley is shown here in a dramatic pose sometime in the 1950s. She was interested in gymnastics and dancing. Her sister Marjorie ran a very successful dancing school in Stourbridge while Hazel went on to become a gym teacher at Hales Owen Grammar School. Their mother Emily had a grocery shop in Cemetery Road during the war.

Left The performer balancing on top is Bob Broadfield, 1956. A pupil at the Grange School under Mr Wooldridge, he then went into the export packing department of Hill, Pritchard & Hill, Hollow-ware manufacturers in Bromley Street. Inspired by films he saw at the Clifton he became an acrobat and joined the Venturas, a circus act travelling all over the world. Now in his eighties he can still perform balancing acts.

1st Stambermill Girl Guide Company was formed in 1943 from a church group of young girls by the vicar's wife, Mrs Edith Burrough. The first captain was Mary Roden with Edna Harris as lieutenant. In 1945 Miss Roden resigned and Miss Harris took over with Beryl Bradley as her lieutenant. In this 1945 photograph are, back row, left to right: Mrs Burrough, Beryl Bradley, Kathleen Brettle, Lilian Cartwright, Velma Boxley and the Revd Mr Burrough. Middle row: Jean Allport, Irene Moore (with dog), Barbara Dunn, Edith Dakin. Front: Margaret Shayle, Edna Tromans, Barbara Brettle and Margaret Burford.

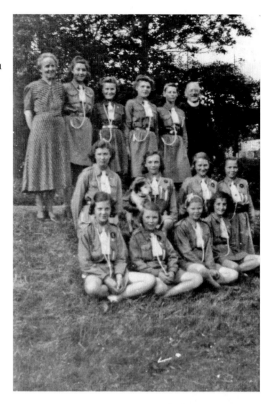

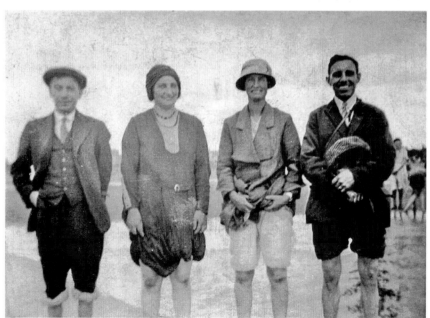

The Dainty family on holiday at Weston-super-Mare, *c.* 1930. Lye folk worked hard and played hard, though not all could afford a seaside holiday like this happy quartet enjoying the opportunity for a knees-up.

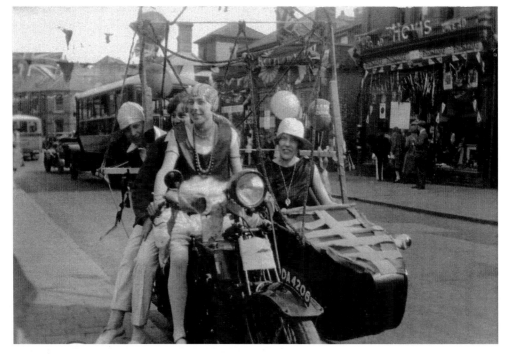

Lye Carnival, 1928. Bill Pardoe, Lye glass designer and photographer, organised this in aid of Corbett Hospital and it proved an outstanding success. Here some of the participants pose on Bill's motorbike and sidecar.

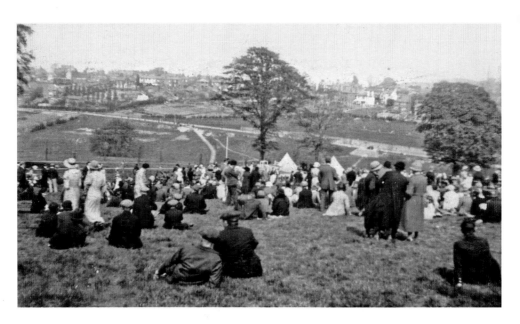

Jubilee day, 1935. Crowds gather in Wollescote Park for the celebration of the Silver Jubilee of King George V and Queen Mary. The newly constructed Springfield Avenue can be seen in the background.

Lye Nursing Cadets with Mrs Price, 1950s. Mrs Price spent many years teaching first aid to both children and adults. She also delivered the post during the Second World War. Lye has a long association with first aid and nursing, starting with Dr Darby in the early 1900s.

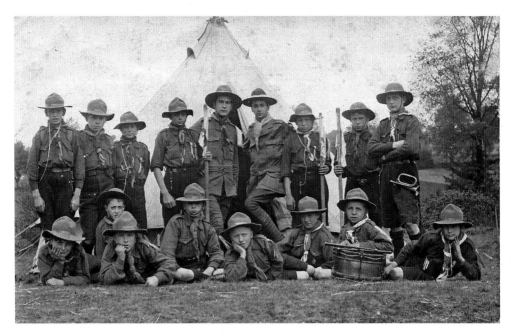

1st Stambermill (St Mark's) Boy Scouts taken on a camp at Hollies Hill, 1 June 1914. The two leaders in front of the tent are Edwin Morris, who later became Archbishop of Wales, and Claude Aston, a prominent Lye figure in later life.

Queen's coronation celebration in the Dock, 1953. On the third row to the right are Maidi and Charlie Darby, and next to Charlie is Alice Crampton, who kept a coal yard in the High Street. Next but one to her is Vera Darby. On George VI's coronation day, 12 May 1937, the only child born in Stourbridge Borough was Wendy Madeleine Tombs of Vicarage Road, Lye. She was presented with a silver cup to mark the event, but sadly she died in November the same year and is buried in Lye Cemetery.

TEMP CINEMA, LYE.

To-night at 6.30 & 8.30:
"THE DONOVAN AFFAIR."

WEEK COMMENCING AUGUST 18th.
Monday, Tuesday and Wednesday,

HIGH TREASON

(ALL-TALKING).
Depicting London in 1940.
Supported by FELIX CARTOON.

Thursday, Friday and Saturday,
KEN MAYNARD in

SENOR AMERICANO

(Silent).
And "THE JADE BOX" (Ep. 2) and
TALKIE COMEDY.
Popular Prices, 4d., 6d., and 9d.

1C

An advertisement for the Temp Cinema from 1930. *High Treason* was a 'talkie' set in a futuristic 1940 starring Benita Hume and Jameson Thomas.

7

PEOPLE

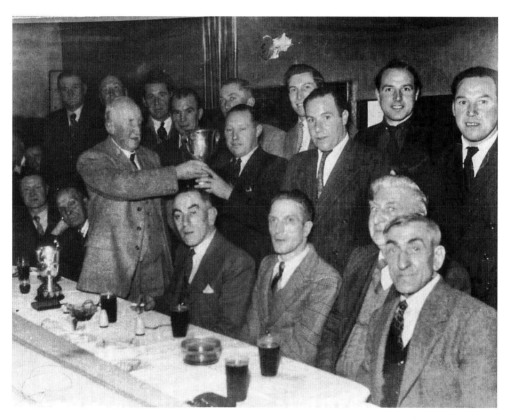

Mr Ernest Entwhistle presenting the cups to Lye Bowling Club, 1950s. A prominent Lye personality, he owned the Danic grocery shop in the High Street and the Temp Cinema (previously the Temperance Hall) in Church Street. Years ago Lye boasted three cinemas – the Temp, the Vic and the Clifton, the first now demolished and the latter two supermarkets.

Mary Taylor in the 1880s. Mary's husband Amos Kenrick died young, leaving her to bring up their children. To earn a living she worked in the brickyards – her fingers bearing witness to this. She loved crocheting and no doubt is wearing one of her own designs.

William Green, Lye's rating officer, with his wife Elizabeth and daughter Elsie, *c.* 1910. They appear to be at the seaside, but this is a studio portrait. During the First World War William was a conscientious objector.

William Green in another studio portrait, this time in police uniform. William was never in the police force, so this photograph is a bit of a mystery!

William Pardoe (born in 1828) is seen here posing by the cascade in the dingle at Wollescote. This photograph was taken before 1900 by his son William (born in 1862), who was a photographer by trade.

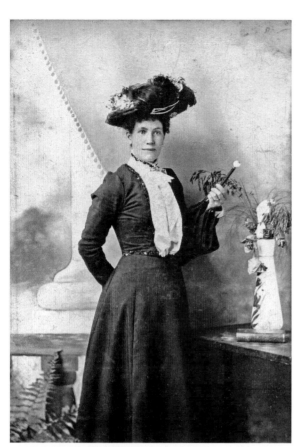

Left Myra Pardoe (*née* Homer) photographed by her husband William in his studio in the 1890s.

Below The Aston/Pardoe clan, *c*. 1895. Pictured on the back row are Fred Aston (b. 1893), Harriet Aston (b. 1889), Zu (Azubah) Pardoe (b. 1887) and Florence Pardoe (b. 1889).

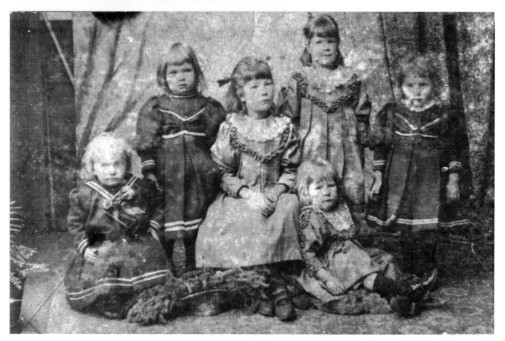

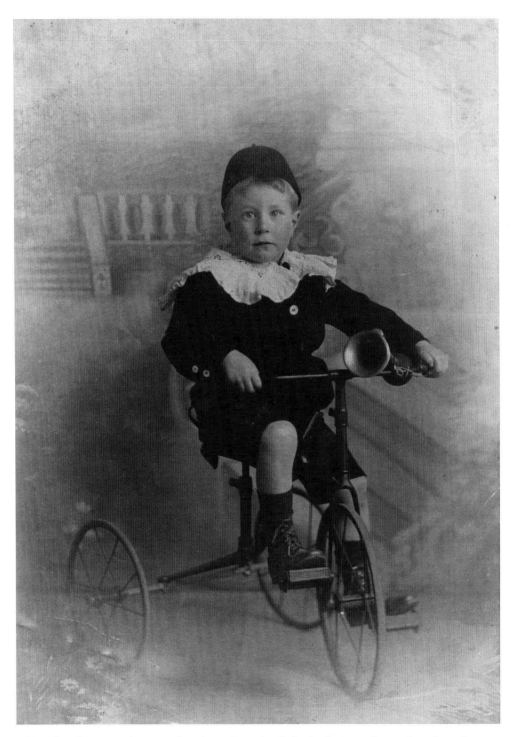

Bill Pardoe (born 1904) pictured on his trike in his father's photographic studio. The trike was often used as a prop in portraits of young children. The painted backdrop also appears frequently.

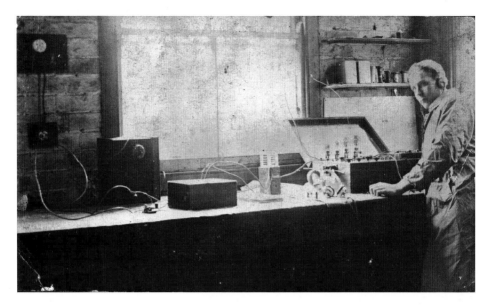

Bill's father paid for his daughters' education but not for Bill's, although he eventually went to Stourbridge College of Art. Extremely bright and outgoing he had many interests apart from glass design and photography. This photograph shows him experimenting with early radio. His last great project was writing the history of Witley Court.

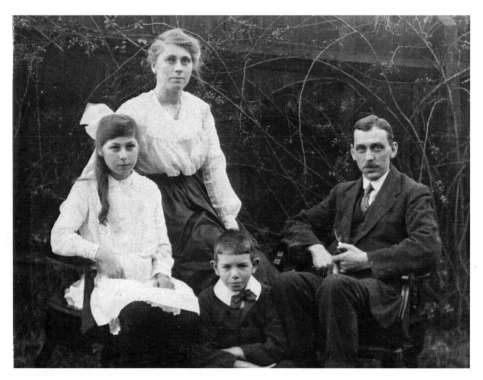

Louisa and Howard Pearson and their family, *c.* 1914. Nora, the daughter, married Bill Pardoe. She and her parents helped Mrs Herald with her theatrical ventures.

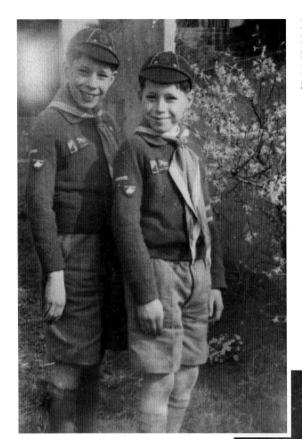

Darroll and Arlen Pardoe were Bill and Nora's sons. Here they are in the uniform of the Primitive Methodist Chapel Cubs on St George's Day, 1955.

Amos Perrins had a nail shop in Bald's Lane and was a well-known figure in Lye. He was a founder member of the Bethel Chapel and its school superintendent for thirty-eight years. Active in local politics, he supported women's rights helping Mary McArthur, leader of the Cradley women chainmakers' strike.

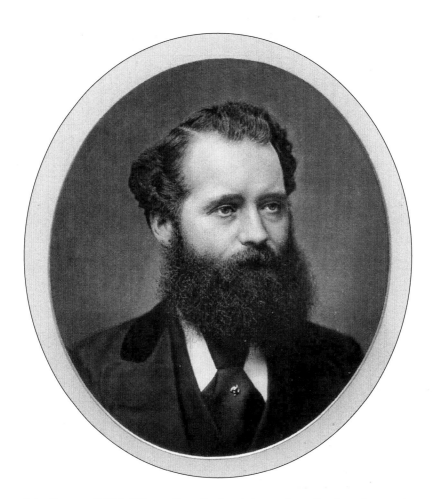

John Pearson (1835–92) was the self-educated son of a nailmaker who rose to become an influential member of the community in the 1870s and '80s. He championed the cause of the chapelgoing community in their efforts to establish a board school and cemetery. He set up the Lye Co-op in 1861, directing its activities until his death.

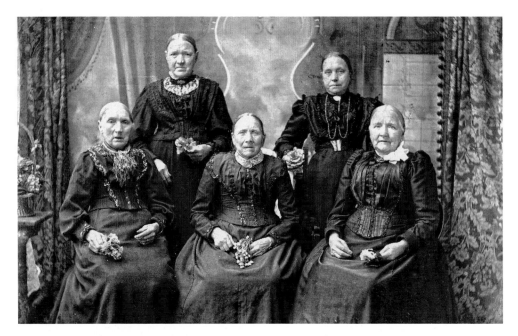

The Hill sisters, *c.* 1900. Each member of this formidable quintet holds a nosegay, an unusual accessory. The photograph is useful for the detail it provides of late Victorian female dress.

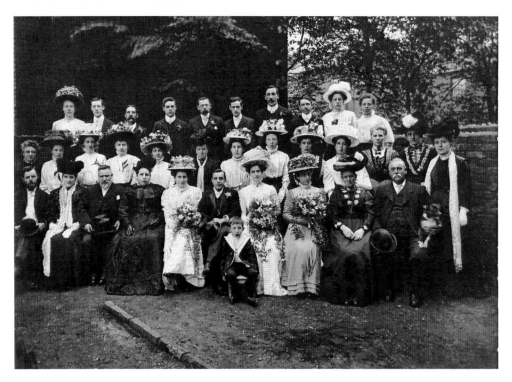

The Lucas family at a wedding, *c.* 1910. A well-known and highly respected Lye family, they obviously were very fond of their pet dog.

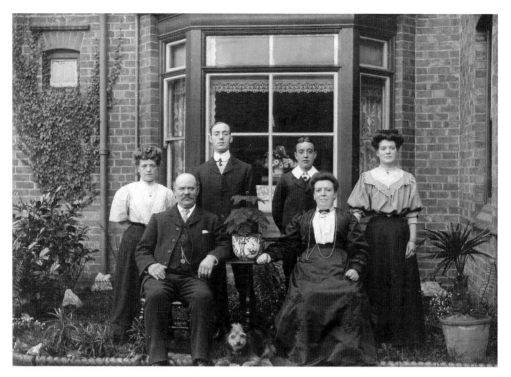

The wealthy Round family photographed at their house in Hill Road, Lye. Their home was close to their factories, manufacturing hollow-ware in Orchard Lane. Standing, left to right: Emily, Philip, Jim and Elizabeth Round. Seated: Philip Round Snr and his wife Mariah. Charlie, the dog in the foreground, was actually stuffed and usually resided in a glass case in the Round family's hallway.

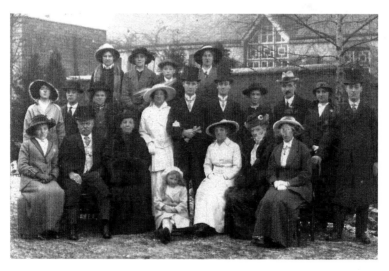

The wedding of Lizzie Round, 1914. Lizzie was a member of the hollow-ware manufacturing family. This was obviously a winter wedding as there is an abundance of fur in the ladies' outfits.

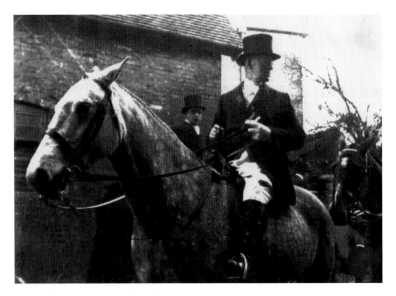

A 1920s photograph taken at Hagley Hall at an Albrighton Hunt sees Philip Round Snr with his horse Silver Tail. His hunting pink was made at Lavenders of Lye. A member of the hollow-ware manufacturing family, he lived at Brocksopp's Hall in Dudley Road before moving to Iverley.

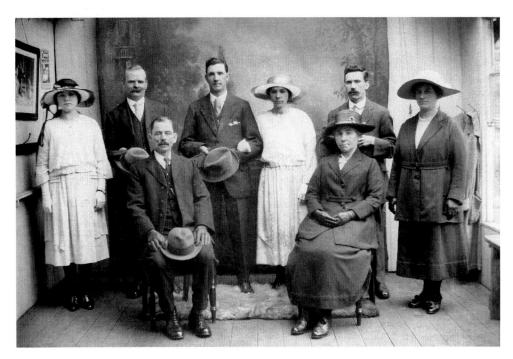

The wedding of Alice Pearson and Arthur Wassell, *c.* 1918. From left to right: Amy Pearson, Hubert Pearson, Arthur Wassell, Alice Pearson, Clem Hazlewood, Hannah Pearson (*née* Hazlewood). The couple seated are not named. Arthur Wassell was an engine driver and Hubert Pearson was a haulier.

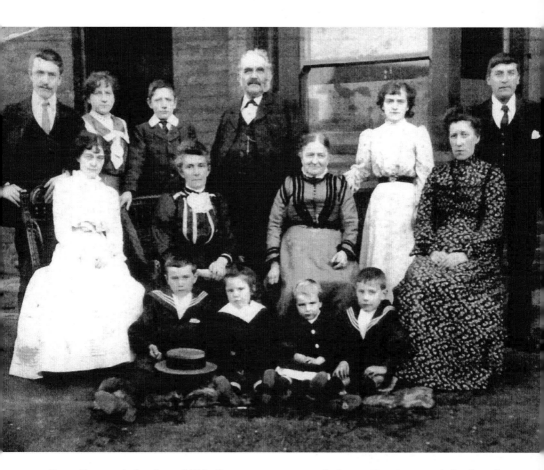

Owen Freeman's family, *c.* 1898. Owen was manager of George King Harrison's brickworks but he was also an accomplished architect. Among his buildings were the Salem and Bethel Chapels and he also designed the brick steeple of Christ Church, Lye, which replaced a wooden steeple in 1885. Missing from the photograph is his son Arthur Owen Freeman who owned the popular chemist's shop in Lye High Street.

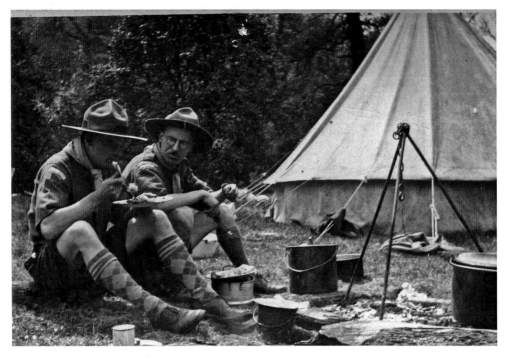

V.H. Skelding (left) and Harry Gibbs, *c.* 1935. Two long-serving, well-respected leaders of the Stambermill Scouts or 'Millers' enjoying a meal at one of the annual camps.

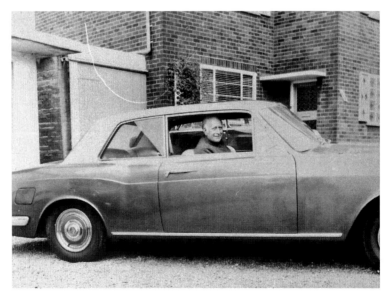

J.V. Kendrick in his later years with his beloved Rolls-Royce. Born in 1922, he was apprenticed to his uncle who was then the Lye undertaker, and ran the firm after his uncle's death.

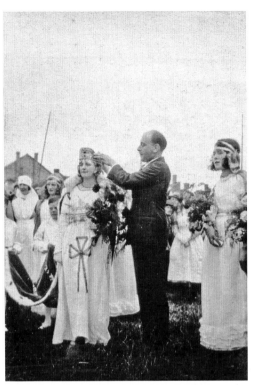

Cedric Hardwicke crowning beauty queen Gladys Price at Lye Carnival, 1930. Born in Lye Cross House in 1893, the son of a doctor, Cedric had been interested in acting since he was a small boy, and was encouraged by his mother and nanny. At first he acted in local amateur productions, then worked as a professional at Birmingham Rep, Malvern and in London. He eventually became a film star in Hollywood. He was knighted by George V who dubbed him Sir Samuel Pickwick because he couldn't hear his proper name.

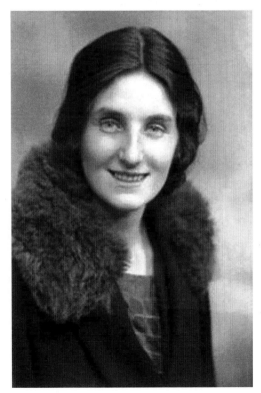

Amelia Halford (*née* Taylor), born in 1904. Many settlers from the Waste had similar physical attributes, such as dark hair and complexion.

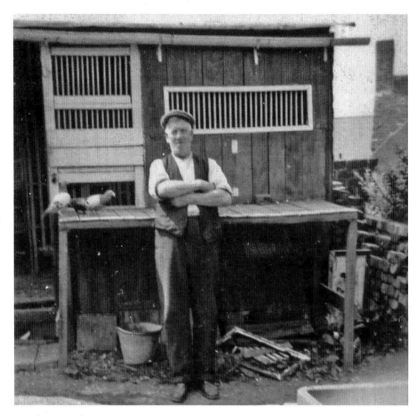

Fred Smith owned the men's tailor's shop in Lye High Street which, unlike most well-established shops in days gone by, is still going strong. His father, pictured here, was a great pigeon fancier. One of his pigeons won the Nantes Cup.

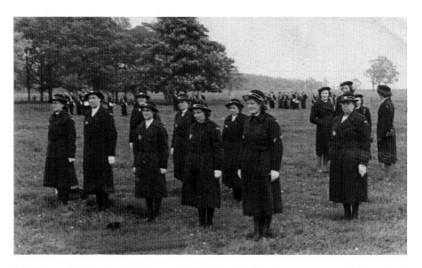

Lye Women's Nursing Division, *c.* 1950. Since Dr Darby inaugurated a branch of the St John Ambulance Brigade in Lye in the early years of the twentieth century, there has been considerable interest in providing a voluntary nursing facility.

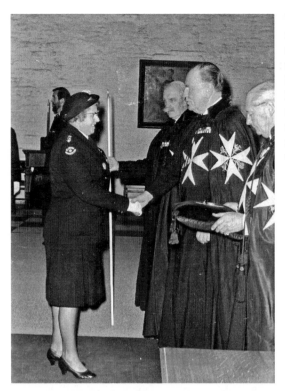

Winnie Wooldridge receiving the insignia of a Serving Sister of the St John Ambulance Brigade in 1968. In her later years she was author of many articles recalling the Lye she remembered when she was young.

Christ Church Lye Anglican Young People's Association was started by the Revd Vickery in the early 1950s. Some of the members are seen here: -?-, Malcolm Robinson, Joan Robinson (*née* Wooldridge) and Derek Allock. Derek remains a stalwart church member, Malcolm died several years ago, Joan only recently. Still working hard for the church in spite of ill health she was always cheerful, helpful and kind.

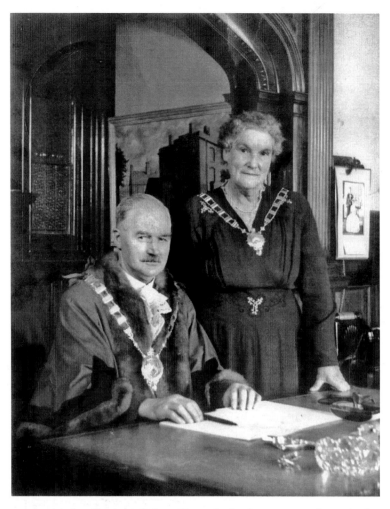

Jimmie Gauden, born in 1886, and his wife Charlotte. Mayor of Stourbridge in 1953 he left school at the age of eleven to work at Mobberley & Perry's and then moved to Wales to become a miner. Returning to Lye in 1925 he became actively involved in politics, serving on Lye & Wollescote Urban District Council and Worcester County Council, among other public bodies.

Margaret Lowe is the wife of Bob Davies, who was the owner of the greengrocer's and general stores in Talbot Street until the area was redeveloped in the 1960s. Having trained as an opera singer at Birmingham School of Music she became a professional soloist performing all over the country until retiring in her early fifties. Margaret still sings with the prestigious Viva Musica Choir.

Cecil Drew (1921–2011). Born in Brook Street, Lye, he left school in 1935 but completed a correspondence course to become a Licentiate of Trinity College, London, qualifying in singing. This enabled him to teach and, ultimately, to become a headmaster. Also a Fellow of Birmingham Conservatoire, he formed choirs and recorder groups and was a soloist, but also advised other singers. This photograph shows him dressed for a concert in about 1940.

ACKNOWLEDGEMENTS

Special thanks must go to Colin Wooldridge for all the help he has given me in coping with technology, also to Ray Griffiths and Harry Rowlands for their work on the 1928 Lye Carnival tape, and to the Black Country Society for help at the launch, my grateful thanks. Also to all of the following who have supplied photographs or information.

Mrs Alix, D. Allock, R. Baggott, Bethel Chapel, Jill Berry, Mrs J. Bishop, the *Black Country Bugle*, Ian Bott, Mr R. Broadfield, Mrs G. Burrows, Mr J. Cartwright, Mrs M. Casey, Mrs A. Chapman, Mr J. Cooksey, Mrs E. Davies, Mrs M. Davies, Mr and Mrs R. Davies, Mrs J. Evans, Revd Simon Falshaw, Mr and Mrs R. Field, Mrs A. Gauld, Mrs E. Griffiths, Mrs M. Hackett, Miss S. Halford, Mr J. Hill, Mr S. Hill, Miss J. Hill, Mrs V. Homer, Mr T. Horton, the late Mr P. Jackson, Mrs S. Jackson, Mrs M. Jones, Mrs P. Jones, the late Mr R. Kendrick, Mr J. Lawson, Mr and Mrs Male, Mrs B. Morgan, Mr J. Morgan, Mr A. Pardoe, Mr D. Pardoe, Mr M. Pearson, Mr and Mrs Perks, Mr B. Pickrell, Mrs Powell, Mr E. Pritchard, Mrs Richardson, Mr B. Riley, Mrs P. Roberts, Mrs J. Rowley, Mrs Rowley, Mrs M. Saunders, Mr and Mrs Shaw, Mr J. Skidmore, Mr Jeremy Smith, Sons of Rest, Wollescote, Mr I. Stinton, *Stourbridge News*, Michelle Tilling, Mrs Mavis Thompson, Valerie, the Bethel, Mrs M. Wakeman, Mr N. Williams, Mrs C. Wooldridge, Valerie Woodhouse, Mrs H. Worton.

Brian Hill (1932–2000). Born in Stambermill, Brian lost a leg in an accident in the early 1940s and had an artificial replacement. He became a cobbler in Stourbridge Road, Lye, and then a bookmaker. He played cricket for Lye and was a good spin bowler and fielder, but had to have a runner when he batted. He was a well-known and well-loved Lye character.